IMAGES
of England

BARTON-UPON-HUMBER

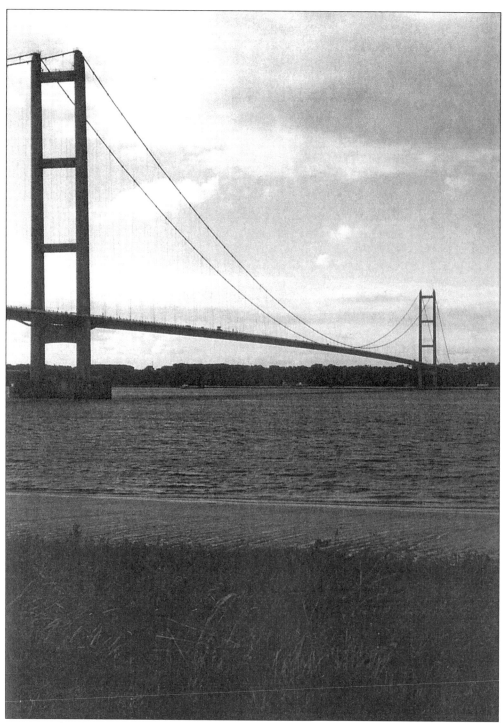

By now a familiar landmark, the twin towers of the Humber Bridge dominate Barton and the surrounding area of North Lincolnshire. Following test borings, the building of the bridge formally began 27 July 1972 and it was opened to the public 24 June 1981. The official opening ceremony was performed by HM the Queen on 17 July 1981.

IMAGES
of England

BARTON-UPON-HUMBER

Compiled by
John and Valerie Holland

TEMPUS

First published 1999
Copyright © John and Valerie Holland, 1999

Tempus Publishing Limited
The Mill, Brimscombe Port,
Stroud, Gloucestershire, GL5 2QG

ISBN 0 7524 1552 2

Typesetting and origination by
Tempus Publishing Limited
Printed in Great Britain by
Midway Clark Printing, Wiltshire

*We dedicate this book to a very dear mother and to the
memory of the Beacroft family*

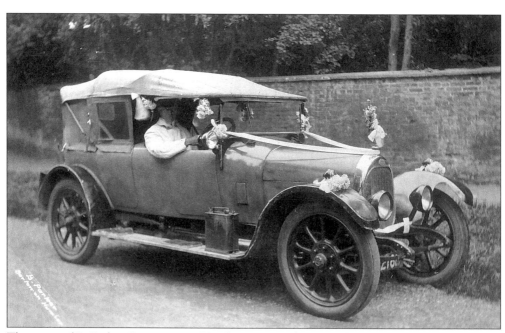

The name of B. Parker, Barton-upon-Humber, is in evidence on the bottom left hand corner of innumerable pictures in old photograph and postcard albums. Most local families had their portraits taken in his studio at 12 Finkle Lane between 1910 and 1930. A familiar figure in the district, he would pedal his bicycle around, camera on his back, to record the notable events of the day, and this despite having lost a leg. By 1926 he had branched out as a motorcar proprietor, keeping his cars in Marsh Lane. He is seen here, seated at the wheel of his car in Preston Lane, all prepared for a wedding.

Contents

Acknowledgements

Most of the pictures in this book are from our own personal collection, built up over the last twenty years. They consist mainly of old picture postcard views taken by the local photographers of the Barton-upon-Humber area almost a century ago. Without these people, books of this nature would be impossible to do. These pictures enable later generations a glimpse of the past in their locality at a time when family cameras were not too common. Although our book could have been completed using only our own photographs, friends and new acquaintances have been both kind and helpful in lending us their treasured pictures to enhance this compilation, as well as giving much useful and detailed information.

Much time has been spent during this year in Barton, especially at the home of our friends, Brian and Muriel Peeps. Brian has given us a tremendous amount of help and encouragement, lending his pictures and offering his local knowledge; nothing has been too much trouble. Muriel has been kindness itself with daily refreshments over several months. Valerie's cousin, Hilda Foster and her husband, Jack, have given us the benefit of their recollections of life and times in and around Barton. Our neighbour, a former Bartonian, Brenda Lancaster deserves a special thank you for always being available with her clear and precise memory and her tons of patience.

The following have helped either with giving additional material or supplying their personal pictures: Roy Cox, Dennis Lawson, Wray Metham, Geoff Reed, John and Lorna Van Den Bos, Fay Shepherd, Henry Hookham, Brenda Foreman, Olive Newmarch, Margaret Akester, Carol Milson, Harold Burkill, Les Marrows, Norman Hebblewhite, Jim and Joyce Johnson. Also many thanks to my dear sister-in-law, Christine Watkins, who took on the arduous job of typing the text in her usual professional manner.

John Holland
November 1998

Introduction

My father had the annoying trait of being somewhat like a squirrel, to the great displeasure of my mother. I can still hear his words 'Don't throw that away it might come in useful, we may need it!' Thank goodness for people like him, with a desire to hoard and hold onto things from the past, leaving us a legacy of riches from another era. I have to confess that I have inherited this habit and from quite a young age I took an interest in family history and life in northern Lincolnshire, where I was born and bred. Together with my husband John, an insatiable desire to acquire photographs of the district has ensued. Postcard collecting is our main hobby and we tour the length and breadth of the country searching out old and not so old postcards of Lincolnshire towns and villages, hoping to add that elusive rare card to our collection. It is almost twenty-five years since we seriously set about acquiring postcards, and I remember vividly the first Barton postcard we purchased, a superb view of the Haven full of sloops and keels.

My first memories of Barton are from just after the end of the Second World War when, along with my mother and sister, we would travel by Tommy Troop's bus to visit the Barton branch of the family. What a wonderful experience that was! Everyone was known by name and delivered to their own front door. For us it was first names, as my mother had lived almost next door to the Troop family before she was married and left Barton to live in Brigg. Throughout my life I have listened to her stories of life in Barton, of schooldays spent at the Church School in Queen Street and, on Sundays, sometimes walking to Barrow to attend church there, 'just for a change'. When not at school, she would help to fetch the cows up from Jacklin's Lane to her aunt's farm in East Acridge, then deliver the milk in cans with her cousin Sarah. Visits to her grandfather were made via the path at St Peter's church, through the spinner, to Green Lane. Shopping was mainly done at Overton Wass's store in Newport, sadly no longer there. Her mother, my grandmother, was a dressmaker and this meant delivering the finished garments to her customers, sometimes for no charge; after all, money was short after the First World War. In compiling this book we have endeavoured to show Barton as it was around this time.

There is a wealth of history in the town which has been well documented by local historians over the centuries. Barton grew and developed because of its position on the banks of the River Humber, and the presence of a good tidal inlet, the Haven. For over 500 years a passenger ferry operated from the landing stage at the Haven to Hull, until it was superseded in 1848 by a new ferry at New Holland. A closely knit community of families lived close to the river, in the area known as Waterside, who were mostly connected with river trade and the industries which

proliferated on the Humber bank. Famous Barton bricks and tiles were produced at dozens of brickyards along the coastline. Chemical works, malting works, a ropery, whiting mills and shipbuilding provided the locals with plenty of work, and the town grew in prosperity. In the early twentieth century this community acquired its own school, church and chapel, and soon became self-sufficient. The town itself has two magnificent ancient churches built within 150 yards of each other, and large chapels were erected in the nineteenth century to cater for the religious needs of the growing population. Perhaps Barton's most famous industry was cycle manufacture. Mr F. Hopper started his business in small premises on Brigg Road around 1870 and soon became successful. He expanded into new factories in Marsh Lane, employing hundreds of men and women, building bicycles that were sold at home and abroad. More housing was needed and this resulted in the development of the Queens Avenue area of the town. By the beginning of the First World War, the population was nearing 7,000.

Barton is an interesting old town with a good mixture of buildings and houses. There are large Georgian houses and imposing Victorian dwellings built for the merchants and land owners of the day, mixed with quaint cottages and terraced homes for the less affluent. With the opening of the Humber Bridge, in July 1981, Barton has renewed links with its Yorkshire counterparts and is now experiencing the wonders of the tourist trade. The town has suffered from the demise of its once thriving industries, but can still be enjoyed as a pleasant town by both its inhabitants and visitors, thanks to the efforts of present day Bartonians, anxious to preserve their heritage.

In common with most villages in the country, those in North Lincolnshire have undergone vast changes. No longer do we find self-sufficient communities with their own post office, village store, school, church or chapel, and a carrier service to connect them to the nearest town. Village life, as it was known for centuries, has been destroyed in the main, by the technological advances of the age. Villages have tended to become dormitories for people commuting to the towns and cities. It is such a blessing that the slower, more peaceful life, enjoyed in these communities, was captured by the cameras of local photographers. We are proud to be able to say we knew the photographer George Parker of Goxhill personally; he was a wonderful, interesting and clever man, who, along with his father and namesake, has left behind a plethora of photographs of Goxhill and around. In addition there was the chemist, Arthur West, at Barrow and Arthur Brummitt of Barton, who, in the early years of this century, recorded life not only in their respective towns but also in the nearby villages. Bert Parker of Barton carried on this practice and let us not forget George Schofield of Barrow.

We have had much pleasure choosing the pictures for this book, and delving into history. We have tried to be accurate, but we do not profess to be experts. Barton and district has local historians who know far more about the area than we ever will. Memories fade and the truth can become embroidered but at least the camera never lies, or so it is said.

Valerie Lois Holland
November 1998

One
The Waterside Area

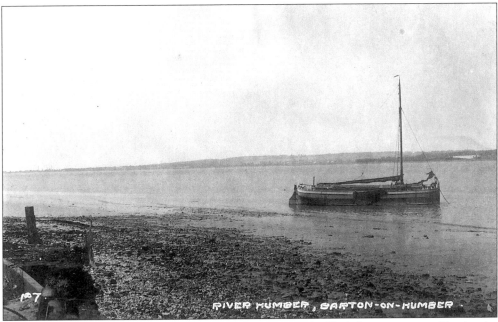

The River Humber in 1946. Looking across the river to the Yorkshire coast near Hessle, the sailing sloop *Adlingfleet* is laid at anchor off the point. The skipper of the vessel is Jack Simpson. Seamen would come ashore in a cogboat as many of them had their homes in Barton, especially in the Waterside Road. The present day Humber Bridge would have occupied the area in the background.

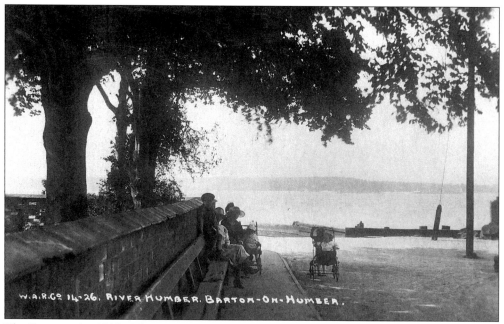

The Point in the 1920s. This was a typical scene on a Sunday in the 1920s when many Barton residents would go for a walk down Waterside. They would sometimes take their picnics and watch the boats on the river. The wall on the left enclosed the coastguard station. This is now a popular area with tourists for viewing the Humber Bridge.

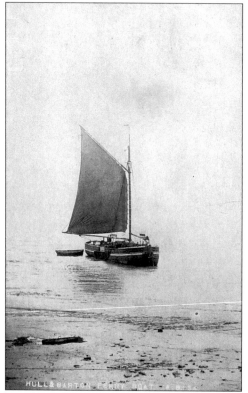

A Barton ferry boat, 1906. A sloop, with the foresail still furled but the mainsail up, is just departing from Barton to Hull with one man at the tiller. This boat would have been carrying general cargo, as the passenger ferry had ceased in 1855. William Stamp owned the rights to the ferry and operated the market boats which plied their trade between Barton Haven and Hull Corporation Horsewash.

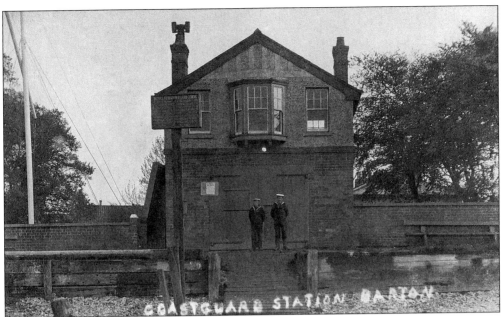

Barton Coastguard Station, 1913. George Rigden was the chief officer at this time and was in charge of seven men. The officer's house used to stand in the grounds adjoining the station. Unfortunately it has now gone, but the coastguards' cottages nearby are still standing. The notice, to the left of the boat house doors, concerns gun practice. Drilling and arms practice were carried out in front of the boat house.

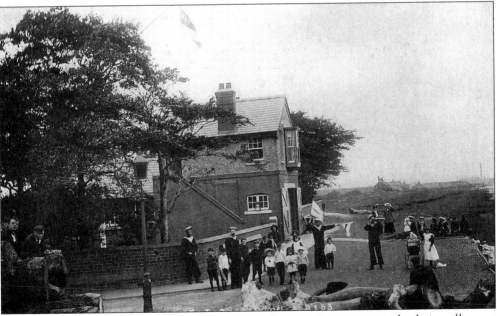

Barton Coastguard Station. Here, the coastguards were in contact with their colleagues stationed at Hessle. Barton was the main coastguard station on the River Humber, controlling the one at Hessle by a system of flag and semaphore signalling. However, by 1919 the establishment was found to be in poor condition and the main boat was unseaworthy. By the early 1920s the station had closed.

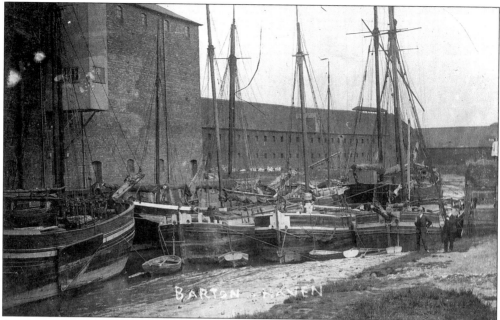

A spectacular postcard view of Barton Haven brimming with keels, sloops and billy boys, *c.* 1908. This was a common sight at the time, as most of the comings and goings of Barton's many industries were done by river craft. The ferry landing stage is on the extreme right of the picture. The maltings in the background have been demolished in recent times.

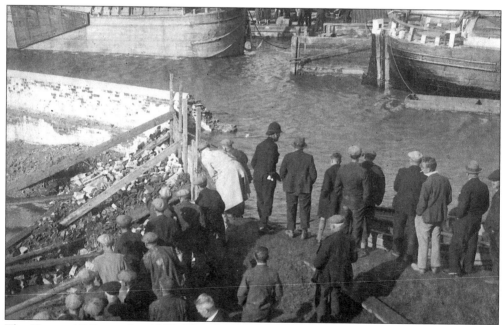

The Haven, 15 September 1935. This date saw a serious flooding of the maltings: properties that were in close proximity were badly affected. The remains of the wall can be seen shored up on the left, as the menfolk assess the damage. The boats in the background are moored by Clapson's boatyard.

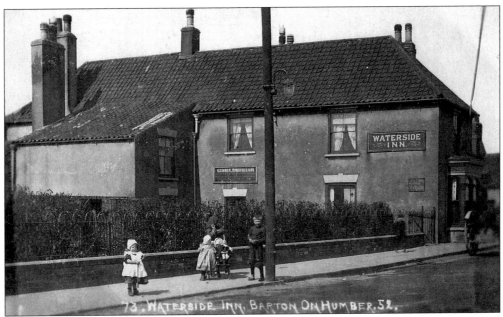

The Waterside Inn, *c.* 1920. George Robinson was the landlord at this time selling Hull Brewery Ales. Situated close to the Point, it was a busy coaching house in the eighteenth and nineteenth centuries and was frequented by passengers using the ferry to Hull. Times have changed. The inn ceased trading around 1960 and is now a private residence. The bay window has gone and the cellar has been filled in.

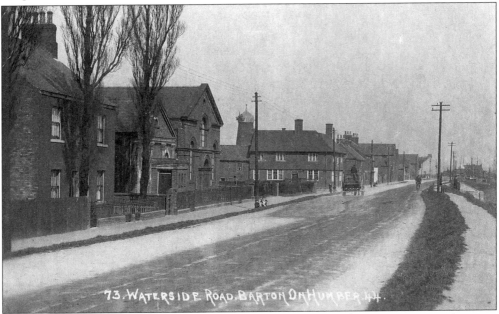

Waterside Road. At the end of the First World War, Barton's roads were in poor condition, as can be seen here. A water cart is wending its way towards the Sloop public house at the corner of Far Ings Road. Its purpose was to dampen an otherwise dusty road surface. The dominant building on the left is the Wesleyan Methodist mission church erected in 1882, which unfortunately now stands derelict.

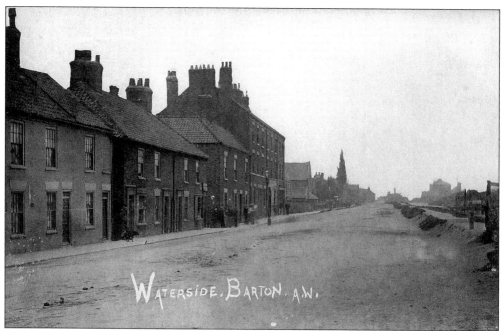

Waterside, *c*. 1905. This is an earlier picture than the previous one, and shows almost the entire length of Waterside Road. This tightly-knit community was almost entirely dependent upon the river trade of the Humber and the local industries that developed around the Haven. At the time of this photograph, Jane Garden had a grocery business at No. 39 where the people are standing. A little further along was the Royal Vaults public house kept by James Barraclough.

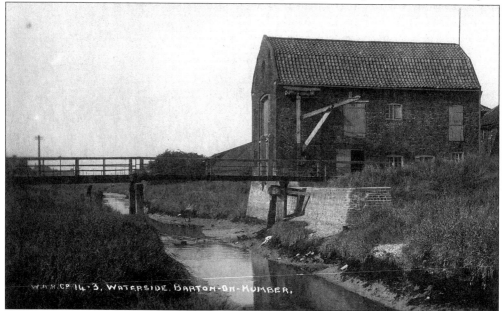

Waterside in the 1920s. The Ropery bridge, seen here, was made to pivot, in order to allow boats further up the Haven. The bridge disappeared in the 1980s, as it was in a poor state and needed a lot of repair. The building was the dispatch department for the Ropery and the crane was used for the loading of the ropes. The building is still standing but not in use.

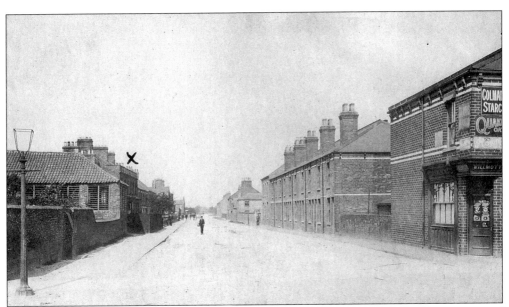

Dam Road, 1906. Before being given its present name, this road was known under a variety of names including Gasworks Lane and Upper Ings Road. On the corner of Dam Road and Waterside Road is Mrs Maria Willmott's general store. It is pleasing to see that there is still a store on this site at the present time and that this part of Dam Road remains largely unaltered.

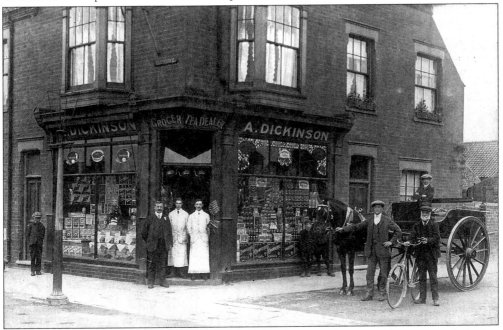

Fleetgate. Arthur Brummitt was responsible for this superb postcard picture of Arthur Dickinson's shop situated on the corner of Dam Road and Fleetgate. It was taken at a time when McVitie and Price's Shortie Biscuits sold at 7d per pound. Familiar names of today can be seen in this wonderful window display, particularly Rowntree's Cocoa, Crawford's Biscuits and HP Sauce. Dickinsons were in business here for over a quarter of a century. In more recent memory the store was acquired by Melias Ltd.

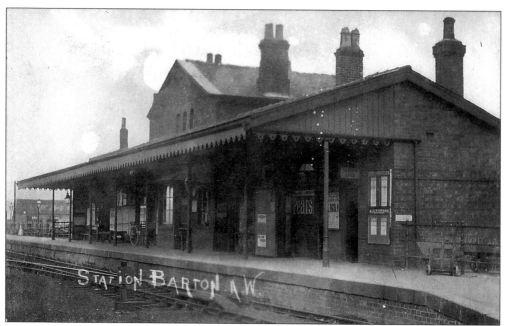

The railway station, 1908. The station opened for service 1 March 1849. On either side of the two-storey stationmaster's house are single-storey offices and facilities. At this time the stationmaster was Francis Peasegood and the station part of the Great Central Railway.

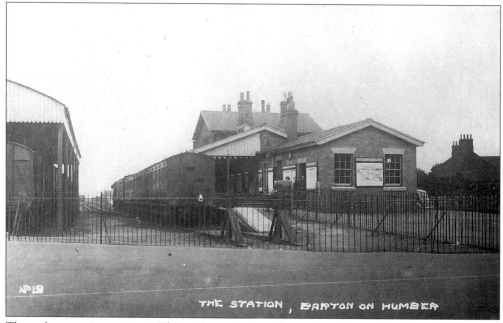

The railway station, c. 1930. This wide-angle view shows the additional booking hall that has been added on to the station and the goods sheds to the left; there is also a train standing at the single platform. The iron railings remain today, but all the buildings are gone, replaced by the usual shelter. At least a rail service still exists!

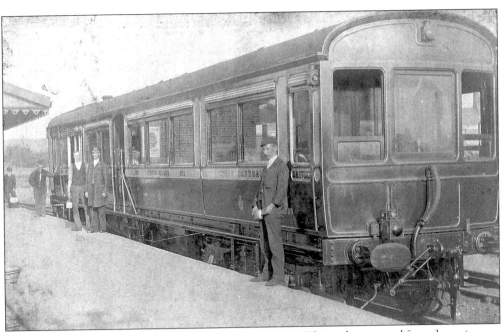

A Great Central steam railmotor at Barton station, 1908. This only operated for a short time on the Barton to New Holland service. The stationmaster is resplendent in his frock coat as he poses with other railway workers for this photograph.

Butts Road, 1905. The house stands almost on the corner of Fleetgate and Butts Road, next to the White Swan Hotel, and opposite the railway station. High on the gable end is a stone set in the brickwork. It states, 'Boundary Line – 18 – 2ft 6ins – 88 – Beyond This Gable'. The house, complete with this stone, can still be seen today.

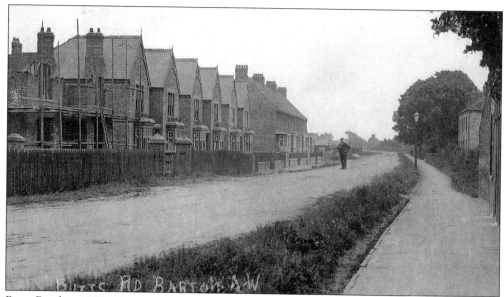

Butts Road, *c.* 1908. Thriving industries and an expanding population necessitated the building of more and better quality houses in the town and much of Butts Road was developed at this time. This view was taken from the railway station end of the road and features the construction of a row of eight fine villas. Nos 1 and 3, known as Shirley Villa and Avondale Villa await completion for the first occupants, Mr H.T. Devonport and Mr T.F. Bennett, respectively. Mr William Tomlinson at No. 5, Wynyard Villa, the works' manager of F. Hopper's Cycles, appears to have moved in already.

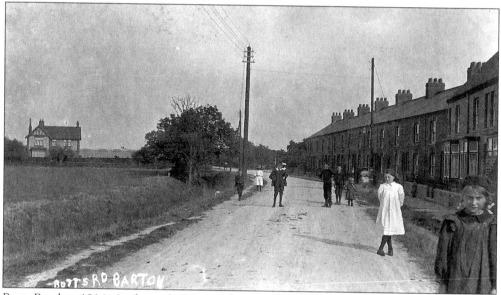

Butts Road, *c.* 1914. At the end of the road, close to the junction with Pasture Road, are the terraced houses known as Aimwell Villas. The open space opposite is the ground belonging to Barton Cricket Club where you can still see games being played today. The large residence and greenhouses in Pasture Road, are the property of Mr John Ducker, the nurseryman. For many years he was one of the main users of Stamp's market boats to Hull, where he sold his produce at the fruit and vegetable market.

Two
The Old Streets
and Lanes

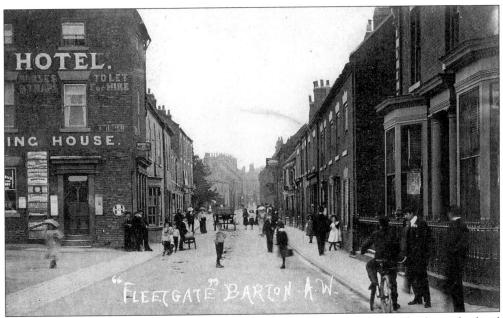

Fleetgate, c. 1905. This superb postcard view of Fleetgate was caught by the lens of a local photographer almost a century ago. It captures a moment in time, with an abundance of children, a cyclist, a small handcart and, in the distance, a horse and cart belonging to F. Hopper and Co. The street, bustling with activity, is dominated by the White Swan Hotel on the corner. Familiar local names can be seen, such as Martin Jubb, C.H. Kirkby, F. Hopper and Co. and Fox-Smith can be noted on the advertising board by the hotel door.

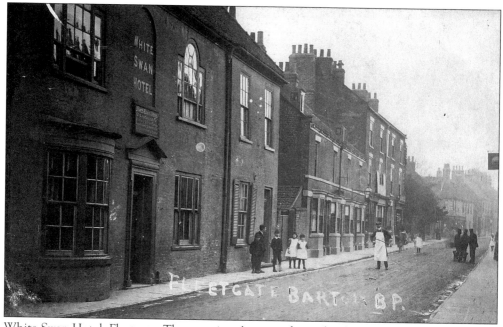

White Swan Hotel, Fleetgate. The proprietor's name above the doorway is James Edwin Ross, the landlord of this busy hostelry adjoining the railway station. In late Victorian times it was advertised as a posting and commercial house providing first class stabling, a bowling green and quoit grounds.

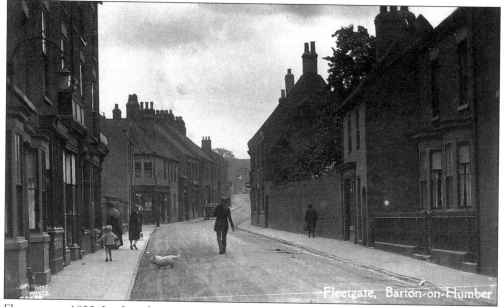

Fleetgate, c. 1930. Looking beyond the White Swan at No. 54 is the fresh fish shop of Charles Harness advertising his daily supplies. At No. 38, on the corner of Newport, is John Rowley's grocery store, but this property is no longer to be seen. Just visible at the end of Fleetgate is the Waverley Commercial Hotel. The lady to the right is walking by Charles Collingwood's mineral water factory situated behind the high wall and next to Charles Clipson's shop at No. 51.

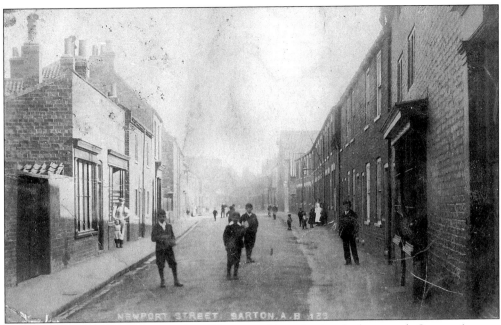

Newport Street, *c.* 1905. Turning from Fleetgate, this early view looks towards Queens Avenue and remains much the same today. Where the gentleman and child are standing was Arthur Lovett's bootmenders shop, now it is a greengrocery.

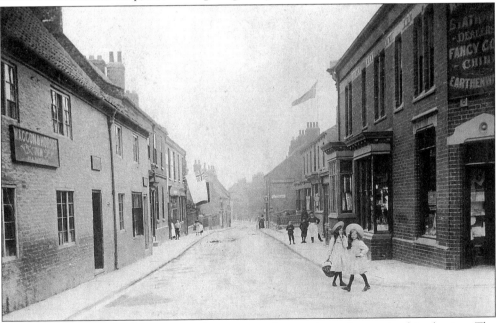

Fleetgate, viewed from the opposite direction to the previous pictures in this chapter. The postmark on this picture postcard is dated 1905 when Alice Parkinson kept the Waggon and Horses Inn. This property was demolished before the Second World War to make way for the Hull Savings Bank, however, it is now the headquarters of the St John Ambulance. Across the road, on the corner, you can now buy your footwear from Mr Clarke, but in 1905 the Misses Alice and Edith Newham were selling stationery, china and fancy goods.

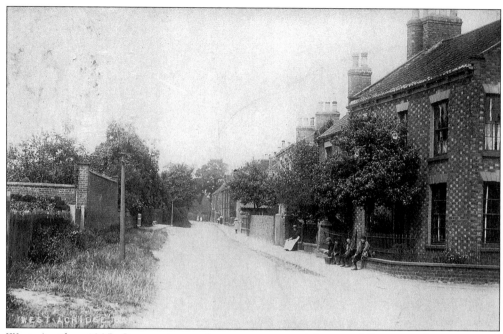

West Acridge, 1905. Contrasting to the more commercial parts of Barton is this quiet rural scene. The street consists mainly of private residences leading to farmland. The boys, taking a rest with their buckets and ropes on the garden wall, may already be having to earn their own living at this tender age.

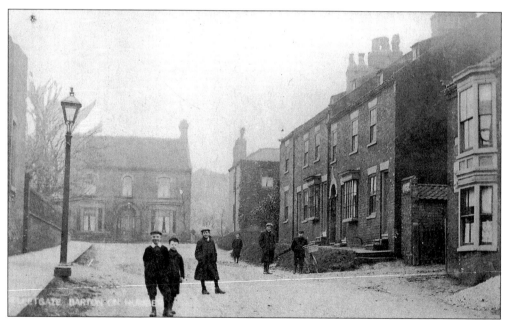

Fleetgate. Through the gates on the right were to be found the premises of William Heaton Wade, millwright and agricultural engineer. He made castings for the sloops and machinery for the brick and tile industry. The only property on the picture not standing today is the one first right.

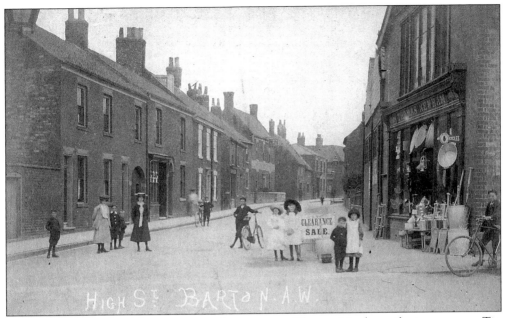

High Street. The sale of the century was in progress at Thomas Newham, the ironmonger. Tin baths and hurricane lamps hang in the doorway, plenty of pots and pans sit on the table outside, and elsewhere there are dolly tubs, dolly legs, clothes horses, wash boards and everything to tempt the housewives of Edwardian Barton. This building was later to become the Star Cinema.

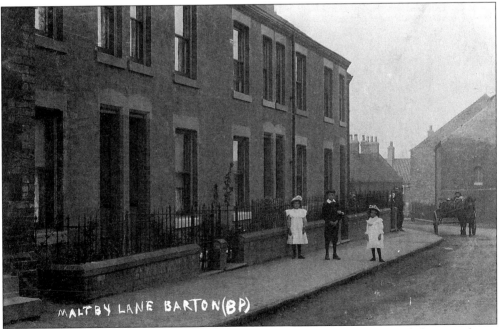

Maltby Lane. Tucked away, off the High Street, this row of houses has stood the test of time and, apart from the absence of the railings, look pretty much the same today. Newport Street is in the distance and the building beyond the horse and cart later changed to become Barton's other cinema, the Oxford.

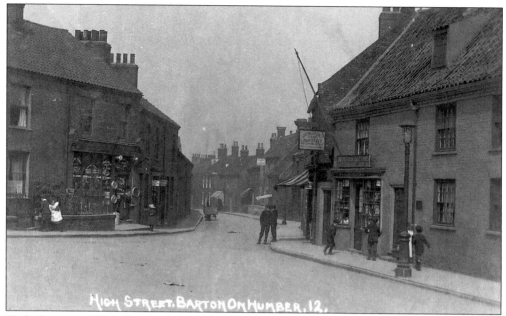

High Street, *c*. 1913. On the left corner stands Richard Ellerby's hardware store, advertising above his façade a host of ironmongery goods including cycles, wringing and sewing machines, stoves, ranges, spouting, household furniture, roofing felt, engine oil, paints and varnishes all at popular prices. Two boys are peering into the window of Robert Hollingsworth's general store next to the receiving office for the Barton and District Steam Laundry.

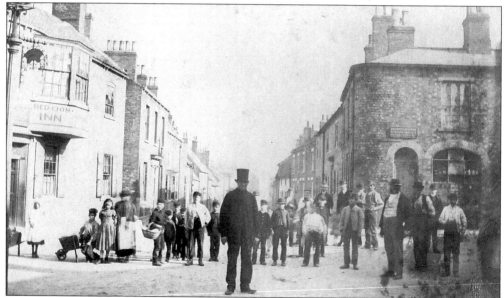

Junction Square in the 1860s. This is a nineteenth-century photograph put, unusually, onto a 1900s picture postcard. The locals would have been told to stand very still as they posed outside the Red Lion Inn. Who can the central figure be? At least we can recognize the shop occupied by Rebecca Harker, a licensed dealer in tea, coffee and tobacco. In her shop window, a poster for Hull Fair is just discernible. Also the name of the licensee of the Red Lion Inn, J. Marshall can just be made out, painted on the wall of the hostelry.

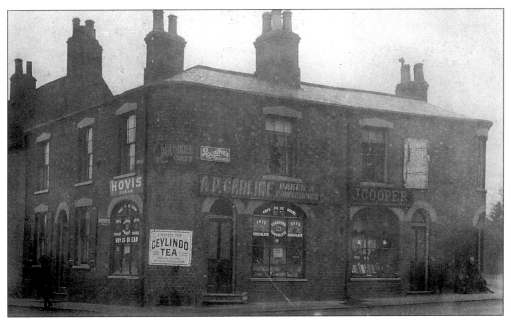

Junction Square. By 1905 Mr Arthur Priestly Carline, baker and confectioner, was in business at this shop which also featured in the picture opposite. In contrast to Rebecca Harker, he had his name prominently displayed on the premises. Next door was John Cooper, a tailor and outfitter, boldly displaying the latest in men's braces.

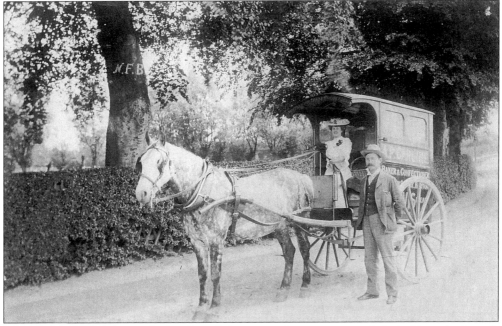

No wonder the gentleman looks pleased, having such an attractive lady holding the horse's reins of his delivery van. The van belonged to A.P. Carline, can it be Mr Carline himself? The van is loaded with baskets filled with bread made in his bakery in Hungate. The Reliance Bakery as it was called, was also open for public baking: bread at 9.30 a.m., cakes and pastries at 2.30 p.m.

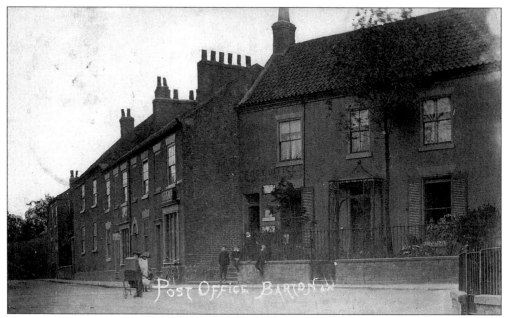

The post office, 1907. It is difficult to envisage the site of this building in Junction Square now as there have since been many changes. Mr M. Woodall was postmaster here for eighteen years until his death in 1909. He was then succeeded by George Morley. Miss Elizabeth Stamp, the milliner, had a shop next door where the cycle is propped. The post office moved to Burgate in the early 1920s.

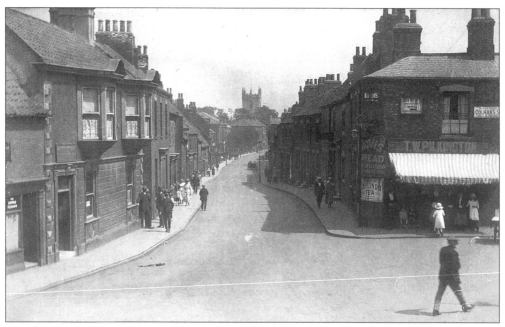

A wide angled view of Junction Square and High Street, with St Mary's church in the distance, c. 1925. Thomas Pilkington, the baker and confectioner has succeeded Arthur Carline, who had moved to the Waverley Commercial Hotel. On the extreme left, Walter G. Stark had a newsagent's shop in addition to being the landlord of the Red Lion Inn next door.

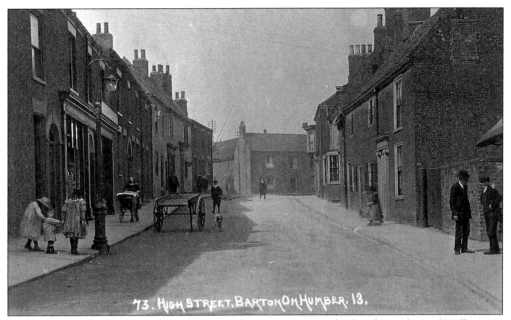

High Street, *c.* 1920. Looking back towards Junction Square, the butcher's shop of William A. Cox at No. 59 can be seen just past the street light, with Wyles, the boot dealers next door. A.P. Carline had, by now, ventured into a new business of motorcar hire, according to the sign hanging from his former premises. A lady is sweeping the pavement in front of her home on the other side of the street. These dwellings were demolished to make way for pensioners' flats.

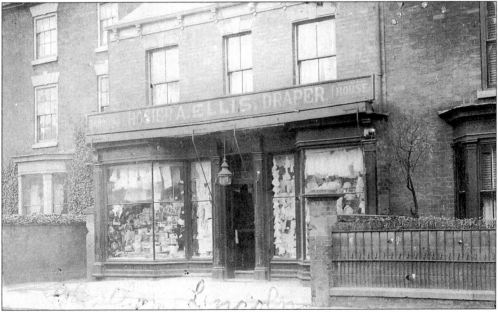

High Street, around 1910. Ada Ellis was a well known shopkeeper to several generations. She started her drapery business in King Street, later moving to High Street where she could be found at Nos 16 and 18, also called Bradford House. A lot of time, care and skill must have gone into producing this display of handkerchiefs and fancy goods in the shop window of her High Street premises.

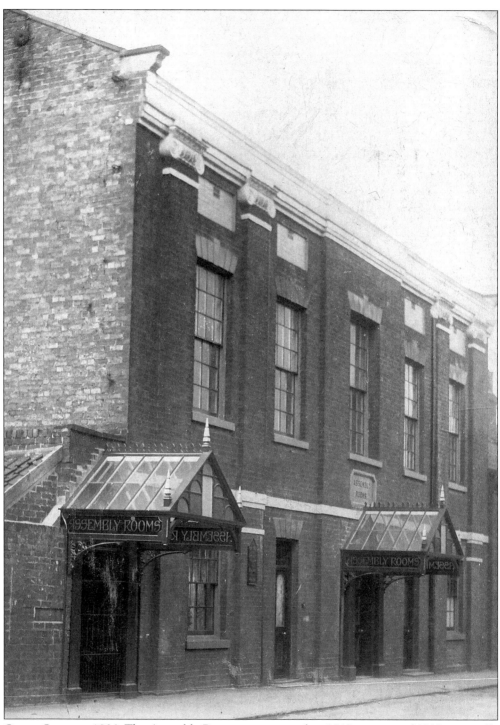

Queen Street, c. 1906. The Assembly Rooms were erected in 1843 at a cost of £700, originally as a Temperance Hall, but closed in 1903. After alterations, it was reopened as the Assembly Rooms and in 1906 was purchased by the parish church. This picture shows a more ornate building, complete with canopies which unfortunately no longer exist.

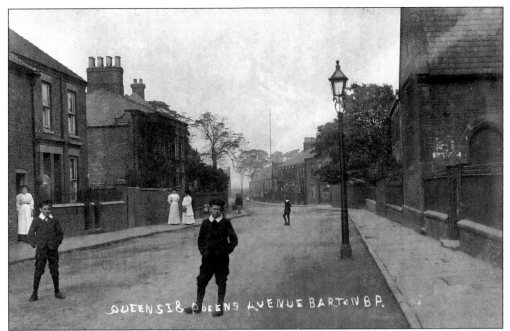

Queen Street, *c.* 1909. On the right is the Church of England school built in 1844. In 1909 the headmaster was recorded as being Mr Solomon Ward with an assistant mistress called Miss Clough. The school remained in use until 1978. Across the street, where the two ladies are standing, is a pair of houses erected in the mid nineteenth century on the site of a charity school. Isaac Pitman, the inventor of shorthand, was the first master.

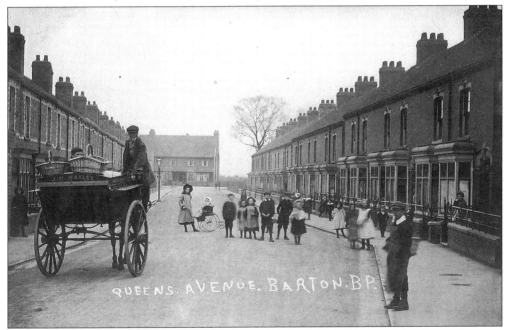

Queens Avenue, 1909. John Herbert Haxley of No. 11 High Street, a pork butcher and grocer, is out on his round in Queens Avenue. This typical street scene photograph is enhanced by a cluster of children obediently posing for the camera. Butts Road is in the background.

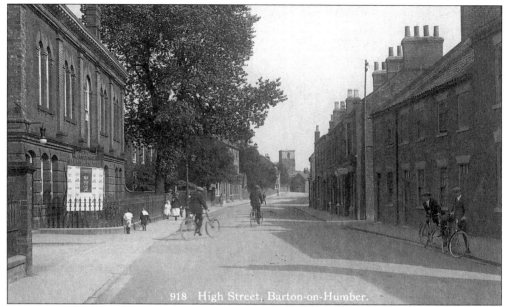

918 High Street, Barton-on-Humber.

High Street in the 1920s. Opened in 1864, the Oddfellows Hall has frontages on to both Queen Street and High Street. It has had many uses in its long life. It became Barton's first picture house and was called the Electric Theatre. This scene shows a large advertising hoarding which states that there were twice nightly shows at 7 p.m. and 9 p.m. for a Sherlock Holmes film. Across the road is No. 11 High Street where John Haxley still had his pork butcher's shop, but by now he was also a proprietor of wagonettes, motor cars, a garage and a funeral business.

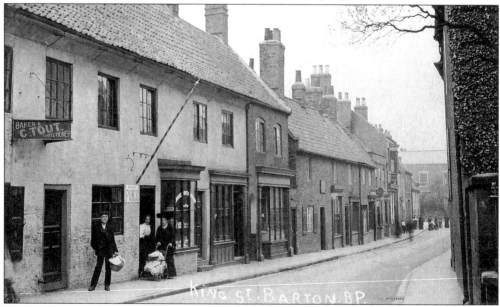

King Street, 1908. A street of attractive little shops where you could find all your needs within a short distance. In 1908 Charles Tout, baker and confectioner, was at No. 1 and at No. 3 was the barber's shop of James Edward Jordan who also sold tobacco. At No. 5 Thomas William Hastings had his greengrocery while at No. 7 sweets were on offer from J. Haxley, the confectioner. On the right hand side of this view is Priestgate House, demolished in 1954.

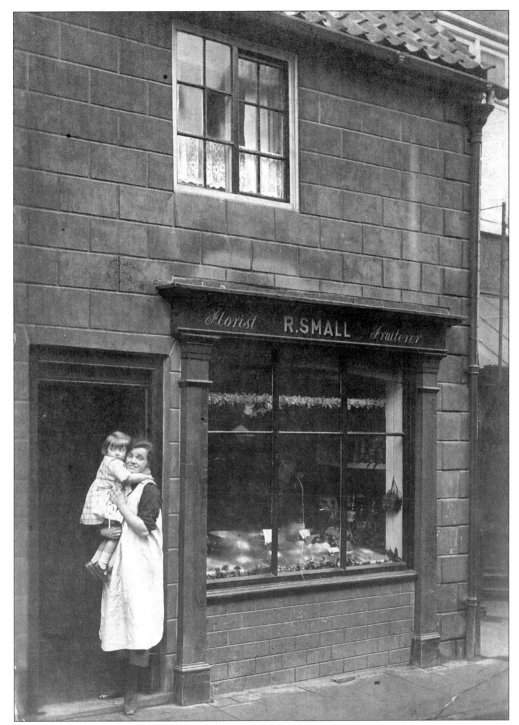

King Street. Robert and Eliza Small had this greengrocery business at No. 13 King Street for many years. The business came from Newport Street around 1909 and continued until the late 1930s. Here, Elsie Small holds her niece Joan in the doorway of the shop which today sells ladies' fashions under the name Frocks.

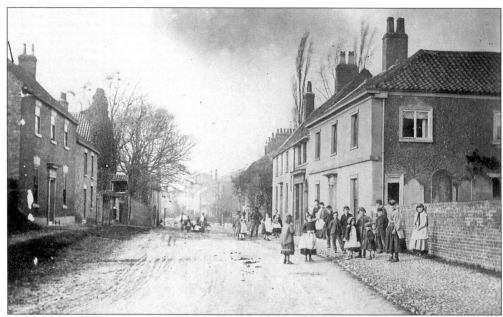

Burgate in the 1860s. This is another older photograph put on to a 1900s picture postcard. The view is taken from close to St Mary's churchyard and is virtually unaltered today. The fine houses on both the left and right sides of Burgate appear the same today: even the tombstones have survived. The children seen here probably attended the Dame School which flourished in Burgate.

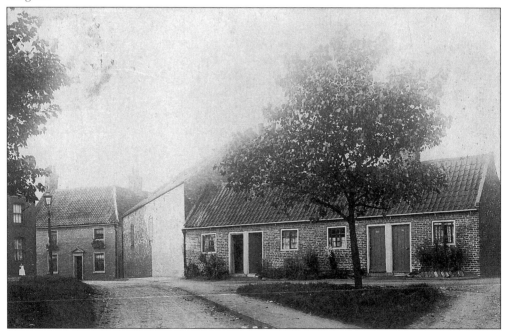

Beck Hill, 1909. This area was known as Nott Hill. The small dwellings were almshouses occupied by poor widows, and were knocked down many years ago to make way for Hopper's expansion. The only remaining building is the white warehouse in the centre of the picture, next to the almshouses, which is to be found in present day Soutergate.

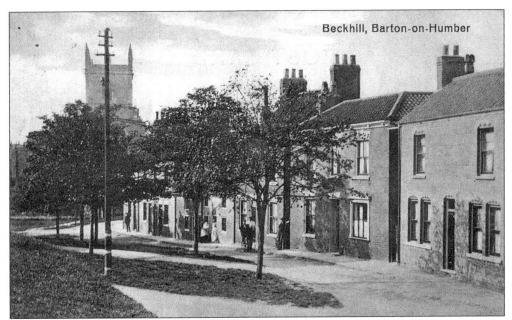

Beck Hill. This picture was published by R. Fox Smith, chemist, on High Street, Barton (now trading as Smith and Webb). This picture postcard view has changed little with the years. It was taken from the churchyard steps of St Peter's looking towards the beck and St Mary's church.

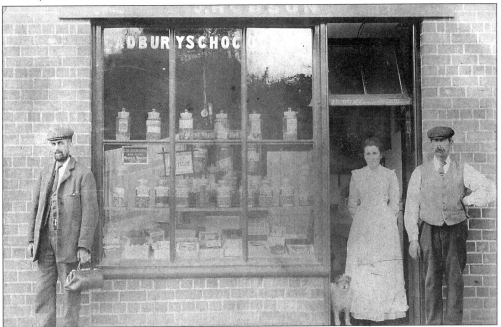

Pasture Road in the early twentieth century. A private house now stands at No. 1 Pasture Road in place of the confectionery shop of John Hobson. This fading early photograph shows a typical sweet shop window from the early part of the century. Mrs Hobson was well known for her catering prowess at birthday parties and teas; trifles were advertised as her speciality. Hobsons stayed in business up to the Second World War.

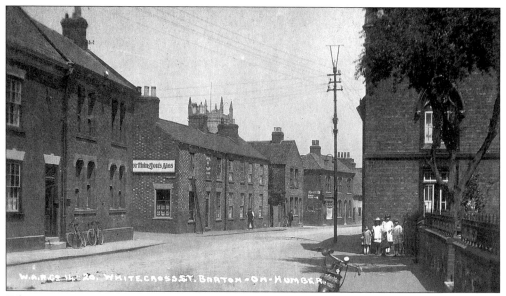

Whitecross Street, *c.* 1928. A pair of cycles lean against the wall of Denby and Co., solicitors. On the adjacent corner of Priestgate, a ladder rests against the upstairs windowsill of the Whitecross Tavern. Further along at St Mary's Lane junction, an old fashioned blind protected the goods in William Cox's shop window from the sunshine. This general store was taken over by Ellen Beacroft around 1930. The motorcycle, registration NL 1120, waits for its rider outside Laurel House.

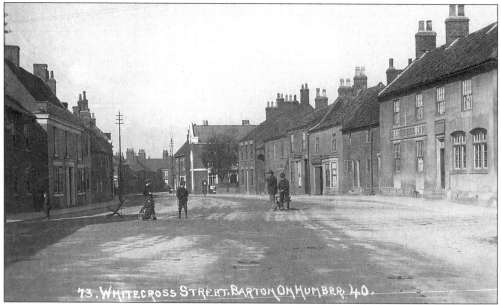

Whitecross Street, *c.* 1918. The great width of the street is very apparent in this view. Above the door of the Blue Bell is the landlord's name, William Langton. The cottages next door have gone, to provide parking space for the pub, since renamed 'Kookies'. The street contains a mixture of buildings from varying periods. Around 1918, the large Georgian house to the left was the home of Dr Frederick Percy Birtwhistle, while opposite lived Henry Ayre, the blacksmith. His was one of three blacksmiths' shops in the town.

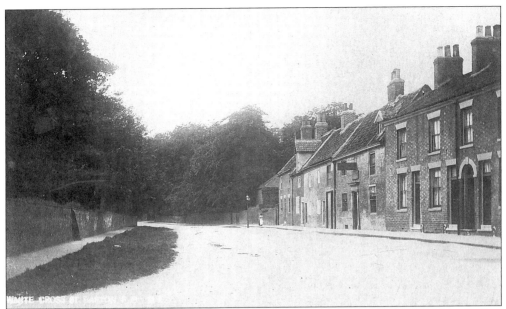

Whitecross Street in the 1900s. Looking towards Caistor Road and Baysgarth House in the first decade of this century, another of Barton's many public houses can be seen. The Volunteer Arms, run for many years by William Topps and later by his wife Mary Ann, gets its name from the contingent of Barton Volunteers formed in 1803 in response to the threatened invasion by Napoleon. It is also known as Crow Trees, a name taken from the large trees in the gardens of nearby Bardney Hall and Glebe House.

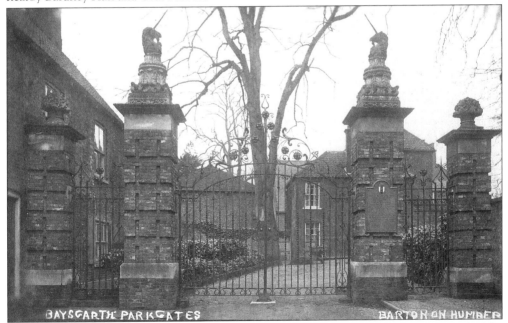

Baysgarth Park. The house and park were given to the town and its inhabitants in 1930 by Mrs Thomas Ramsden, in memory of her parents, Mr Robert Wright Taylor JP and Mrs Clara Louise Taylor, and of her brother, Lt G. Taylor, who was killed at Ypres in 1917. The memorial plaque on the gatepost is now on display at the museum inside Baysgarth House.

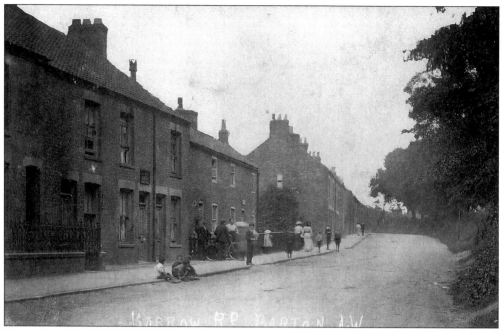

Barrow Road in the 1900s. This scene from ninety years ago shows terraced housing with local folk adding interest to an otherwise ordinary scene. Two small advertising boards can be seen above front doorways, the nearer one referring to 'Dent'. This house is the present day No. 33, the only other differences are a wall and a gate in front. An extra house has now been built at the corner of Green Lane where a large bush can be seen. Across the road nowadays are modern bungalows.

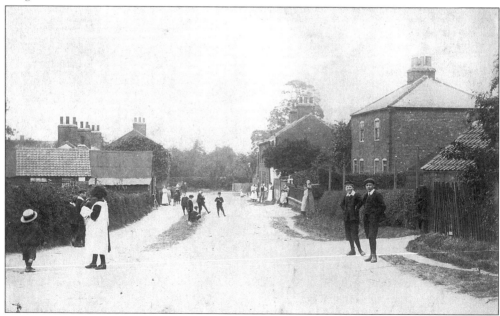

Green Lane, a quiet cul-de-sac with few houses, 1905. It appears that every resident is ready for the photographer. The scene today shows how time has stood still here; the houses have hardly been altered, the trees at the end have grown taller, but the road surface is still unadopted.

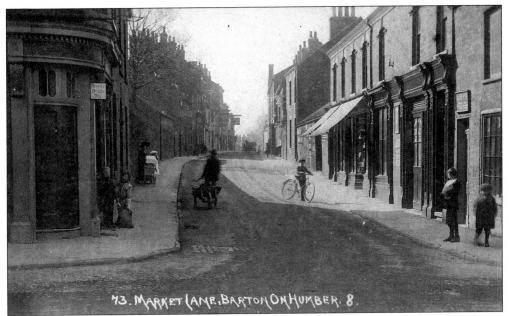

Market Lane, leading into the Market Place, *c.* 1920. Many of these buildings disappeared with the progressive changes that were made in the 1950s. On the right in this view are the premises of Charles H. Kirkby who seems to have sold everything, as well as having the mill in Castledyke. The buildings beyond have gone. To the left, the grocer's shop on the corner of Whitecross Street has also been demolished as part of a road widening scheme.

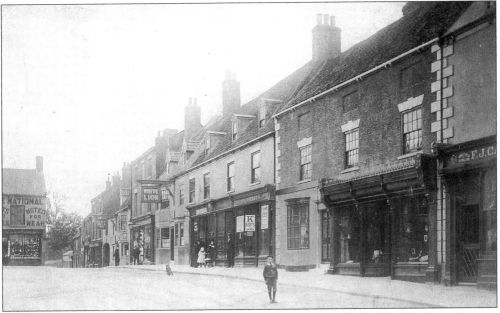

Market Place, 1906. Two of Barton's old inns, the White Lion and the Black Bull, can be seen looking back to Market Lane; unfortunately both no longer survive. The latter was demolished soon after the First World War, the former became part of Dorothy Cox's china shop. The two drapers, John Haslam and Frederick Bourne, and the shoe shops of John Stephenson and Stead and Simpson feature in a more enclosed square than is seen today.

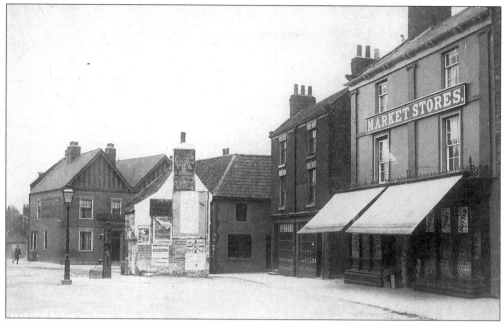

Market Place, 1905. Many changes have taken place over the years, as in the instance of the building festooned with advertisements standing isolated by the pump which is long gone. In 1913 the building partially hidden behind it was replaced by a bank, the National Provincial. The Market Stores shop of John Tutill, grocer, literally fell down 21 January 1985. The remaining building and the George Hotel survive.

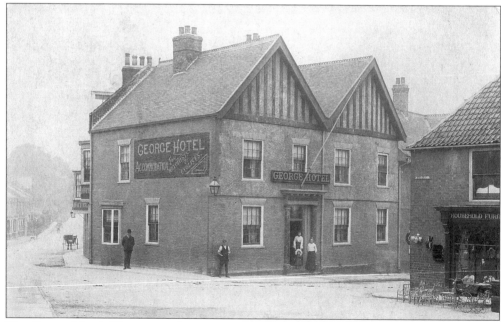

The George Hotel. This postcard view was sent as a Christmas greetings card in 1904 by the landlord, Herbert Gaunt. It is a sign of the times that he is offering accommodation for motorists as well as cyclists. The game of billiards is on offer too, according to the sign above the ladies in the doorway.

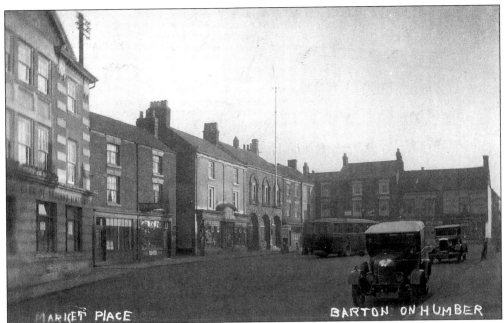

A contrasting scene to the 1905 view of the Market Place opposite. The pump and drinking trough are no longer required as motorcars gain popularity. There is even a telephone box outside the Constitutional Club, as the bus, owned by Enterprise and Silver Dawn, leaves for Barrow. Mrs Alice Blythe has tea rooms at No. 4, and Tutills have a new shop front at Nos 6–7.

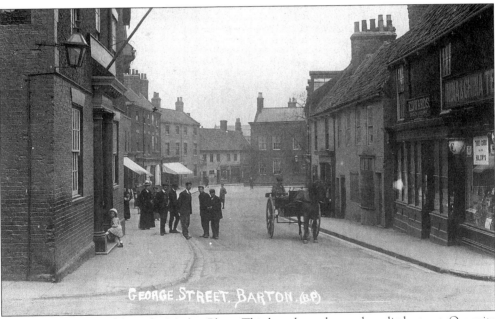

George Street, viewed from the Market Place. This has always been a busy little street. Opposite the George Hotel can be seen two shops, India and China Tea Stores, and Edwards the saddler, just prior to their demolition in 1913. The skyline on this side is very similar today, even the attic windows remain, although the properties have undergone alterations. Priestgate House is visible beyond.

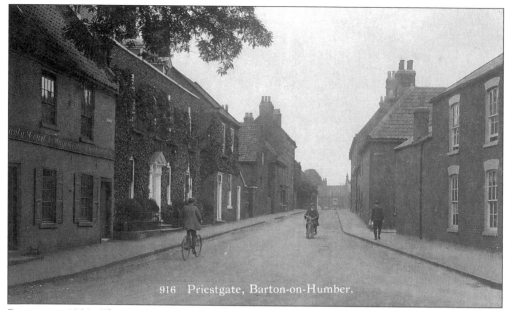

916 Priestgate, Barton-on-Humber.

Priestgate, 1921. This is a street of fine Georgian houses leading to Whitecross Street. The finest is Cob Hall with its columned doorway. First left is the County Court and Magistrates Clerk's Offices, the clerk at the time being Richard Hudson. From the middle of the nineteenth century until 1935, Nos 7 and 9 Priestgate, on the other side, nearer to Whitecross Street, were used as a presbytery and chapel by the catholic community.

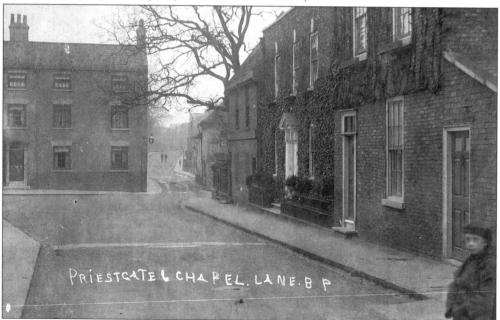

PRIESTGATE & CHAPEL LANE. B P

Priestgate and Chapel Lane before 1914. Postcard views like this one of side streets and lanes away from the usual focal points of towns are scarce. Here is evidence of the contrasting styles of architecture, from the elegant Georgian town houses of Priestgate, to the more humble Victorian dwellings of Chapel Lane. The three-storey building of Martin Jubb divides the two styles on the corner of George Street and Chapel Lane.

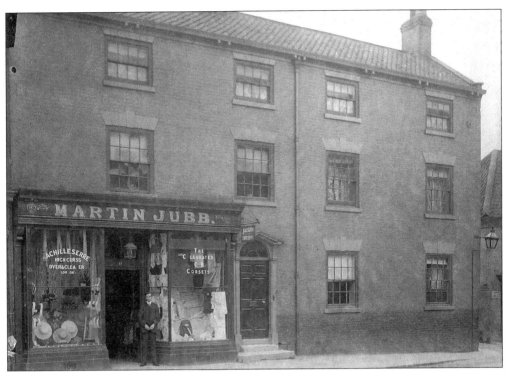

George Street, 1919. Martin Jubb carried on a drapery and millinery business in George Street for forty-six years. A respected tradesman, he retired only a fortnight before his death on 16 February 1920 in his eightieth year. In the doorway is Mr G. Wilmott, an assistant at the time. Deweys, the ironmongers, took over the premises and made radical alterations.

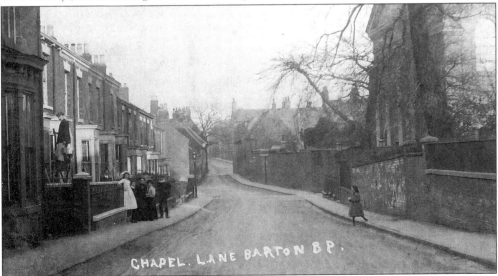

Chapel Lane, 1909. It is so called because of the two chapels in it. One of these, the Wesleyan chapel, can be seen on the right of the picture as we look back towards Priestgate. Most of the high wall, further along, has been pulled down to make way for a car park. The excitement of having a photographer down the lane brought a family to the gate, while even the painter, busy at No. 26, stopped for a moment.

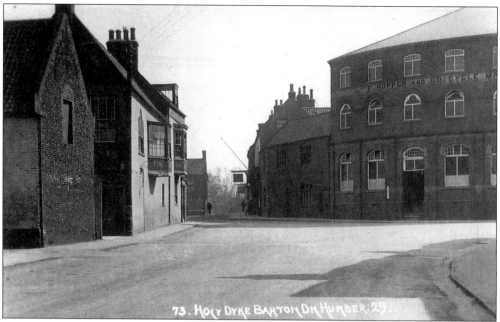

Holydyke, *c.* 1918. On the corner of the Market Place and Brigg Road, stands the substantial three-storeyed office block of F. Hopper and Co., cycle manufacturers. By this time, Hoppers of Barton had achieved worldwide fame as a centre of bicycle manufacture. An earlier picture of the same building has the words 'The Butterfly Cycle Co.' emblazoned on the wall. A Barton foundry was once situated on this site.

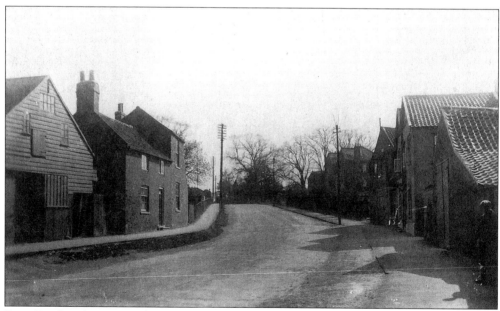

Brigg Road in the 1920s. The houses at this time constituted almost the outskirts of Barton in this direction. The first building on the left is where Ted Dent and Sons had a joinery and undertaking business, while opposite are the house and workshops of Stamp and Son, one of a number of builders in the town.

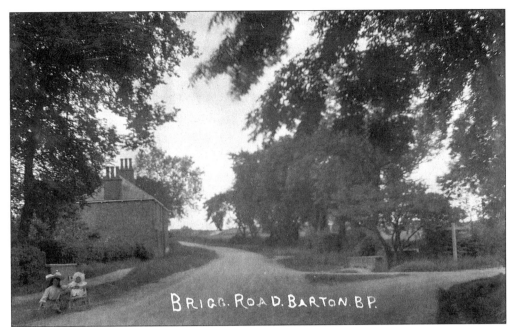

BRIGG. ROAD. BARTON. BP.

Brigg Road, 1908. Out for a walk on a lovely summer's day, a young lady and child paused for the camera at The Bridges. This is the old turnpike road to Brigg at its junction with Horkstow Road, and where, under the bridges, 'slack water' would flow through the middle of the park eventually draining into the Beck; the bridge parapets can still be seen. The house, known as Park Cottage, survives, but not in the splendid isolation it enjoyed in this peaceful rural scene.

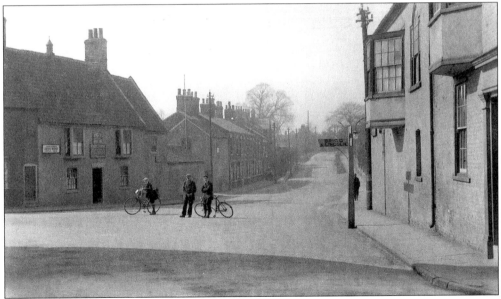

Holydyke, c. 1925. Two of today's busy roads meet where these two men and a boy stand for the photographer. To the right is the George Hotel, with the road sign pointing to Brigg and Lincoln; ideal for boys to swing around! The Wheatsheaf Inn, standing on the opposite side, was kept by Robert C. Stoddart in the 1920s. The adjoining cottage has made way for a single-storey extension to the inn.

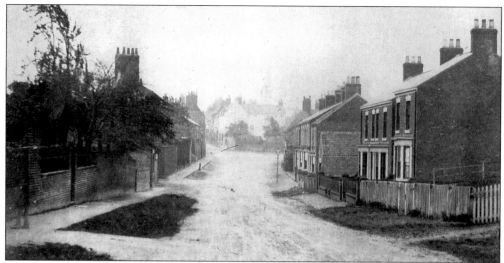

Holydyke. An early view of the street looking down towards the Market Place in the days before Fred Hopper built his large offices. The picture, looking Victorian and rather rural, predates the 1902 building of the lecture hall and schoolrooms for the Wesleyan chapel. The nearest house on the right is No. 19. The Primitive Methodist Parsonage was No. 15 and at that time was known as Ivyville. Fred Hoodless, the carter and carrier, lived in the house beyond the parsonage.

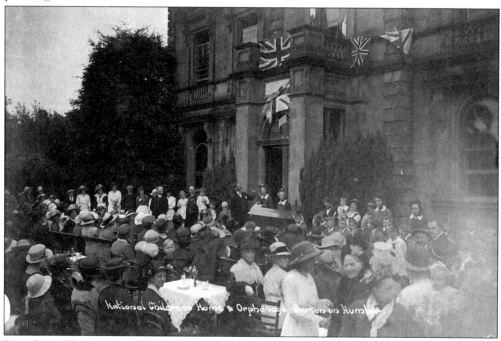

Providence House, Holydyke. Built for Thomas Tombleson in 1854, this was their family home until 1918, when it was bought by the Sharpley family. The house was then given to the National Children's Homes for an orphanage in memory of their son Lt Henry Sharpley who died in France, on 24 March 1918, serving his country. It remained an orphanage until 1940 when the boys were evacuated to Lancashire. In this scene, a stone to Lt Sharpley's memory is being unveiled in the presence of a large audience.

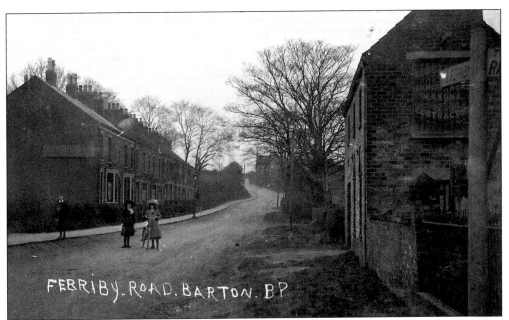

Ferriby Road, c. 1907. The signpost indicates South Ferriby in one direction, and the railway station to the other. George Coulam is advertising his stonemason's business on the wall by the signpost. Beyond George's business Jubb's quarry can be found. To the left of the two young girls is a sign on the wall advertising J. Credland and Co., wheelwrights and timber dealers.

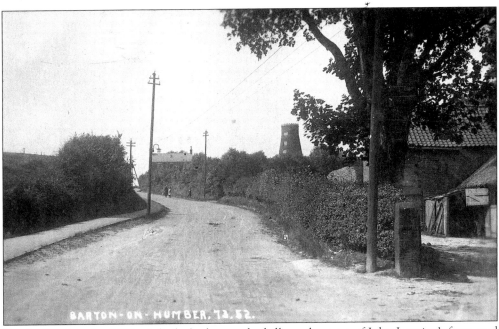

Ferriby Road in the 1920s. A little further up the hill are the gates of John Leaning's farm, and on the skyline is the mill house and mill belonging to George Milson. The sails were removed in 1907, the machinery in 1920, and finally the mill tower was demolished in 1934. This postcard view shows the more rural aspect of the road, contrasting with the enormous housing developments of modern times.

Westfield Road. Another photograph from the camera of Bertram Parker, taken outside Waverley House, now renamed Westbridge House. The horse and cart belong to the Exors. (executors of wills) of William Stamp. Mr Stamp bought the Barton Ferry rights in 1882, and from 1883 to 1956 a regular carrier service was provided from the Waterside jetties to Hull.

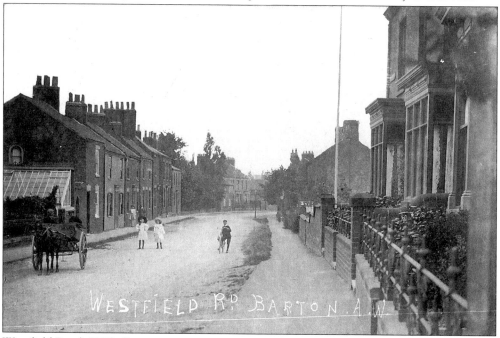

Westfield Road, 1909. Conservatories were very popular in Victorian and Edwardian times, but the one to be seen on the left has now gone to provide access to a garage. On the extreme right is Autumn House, the home of Joseph Barraclough, a member of a well-known Barton family of sloop owners. This was a popular residential road for business people of the time and has changed little over the passing years.

Three
Events and Occasions

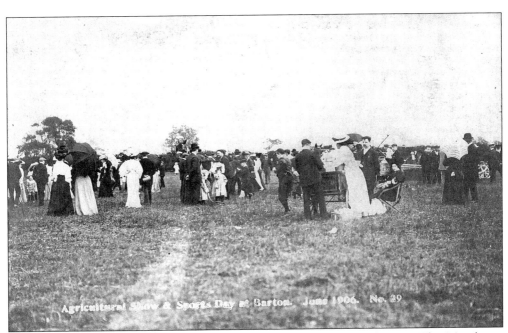

The Agricultural Show at Barton in June 1906. It must have been a pleasant Whit Monday in Barrow Road Park for the annual festivities and judging of entries comprising horses, cows, sheep and pigs. Butter, eggs, bread, poultry and rabbits were exhibited inside a marquee. The show, attended by farmers and hundreds of local people, was followed in the evening by a programme of sports and entertainment.

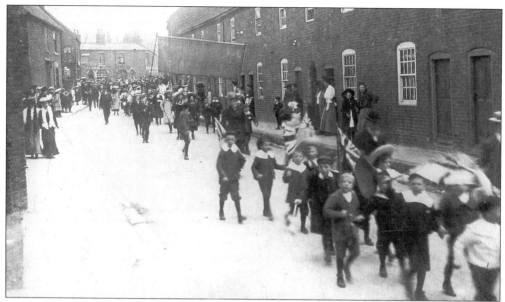

A Sunday School procession. The children of the various Sunday schools in the town are seen here enjoying their annual treat, usually held on Whit Monday. The procession is passing Winship Flags in High Street with the children proudly displaying their respective banners. Members of the Congregational chapel are followed by those from the Primitive Methodist Sunday school. Afterwards the children were treated to tea at their respective schoolrooms.

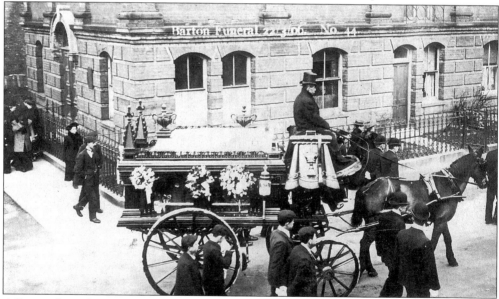

A Barton funeral, 1906. Never before had such a funeral been witnessed in the town as the one that was seen on 22 March. The triple tragedy that had occurred moved the hearts of everyone. Here, the hearse is turning into High Street on its way to the cemetery after a service at the Primitive Methodist chapel. The small white coffins of two little boys, John Herbert Marshall aged eight years, and Donald Marshall aged four years, are placed on top of the hearse. The coffin of their mother, Mary Louisa Marshall, aged thirty-two years is inside the hearse provided by Martin Jubb. Her husband, Walter Marshall led the mourners.

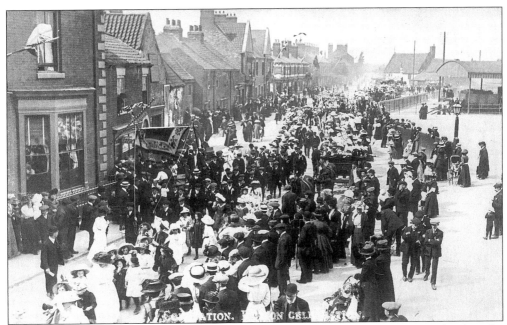

Celebrations to mark the Coronation of George V, June 1911. On a windy but dry day, the town gave itself up to enjoyment in order to make the best of this rare event. The public proceedings commenced at 2 p.m. with the assembling of the various units, which were to comprise the procession, in the Market Place. This picture shows the procession, which was said to be a mile long, proceeding along Fleetgate.

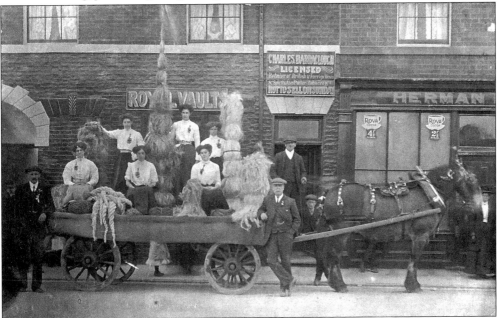

The Coronation, June 1911. Hall's Ropery Company had two decorated wagons in the trade section of the procession, representing the work of their male and female employees. The ladies are posing with their entry in Waterside, outside the Royal Vaults public house and Herman Lacey's shop.

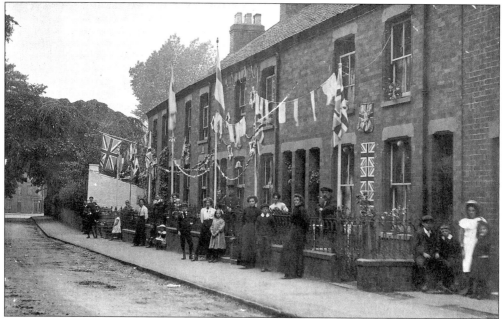

Coronation celebrations, June 1911. The town was ablaze with bunting on a scale far greater than ever attempted before. Streamers crossed the streets at many places, and in the morning the streets were crowded with people admiring the display. Bert Parker, of Finkle Lane, captured this picture of the proud residents of Barrow Road in front of their decorated homes.

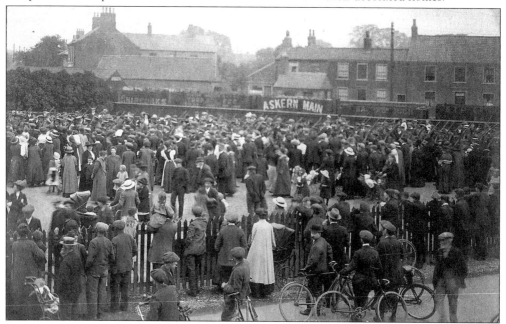

Barton railway station on a crowded Sunday morning with soldiers off to war in September 1914. At eight o'clock, volunteers were preparing to leave for training for a war expected to be over by Christmas. Many of these men were posted to France where they suffered heavy losses at the Hohenzollern Redoubt on 13 October 1915. By 11 November 1918, 165 gallant men of the town had given their lives for King and Country.

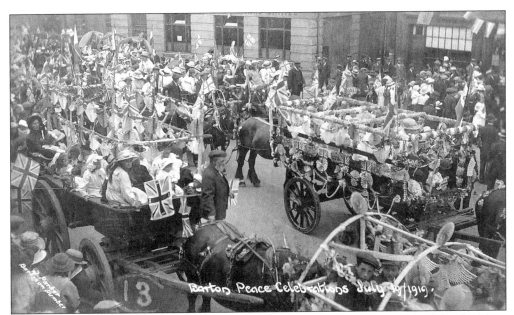

Peace celebrations, 19 July 1919. Barton celebrated the day by a dinner for demobilized soldiers over which Colonel Wilson DSO presided. Various public bodies, Sunday schools and others paraded through the principal streets with prizes awarded for the best horses and wagons. Later, hundreds of children were entertained to tea. The occasion was well documented on film at the time and this print of Market Place illustrates the festive mood of both the grown-ups and children.

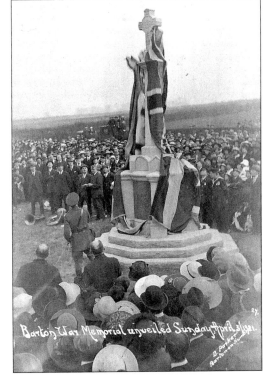

The unveiling ceremony of Barton's War Memorial, performed by Lt Col. H.G. Wilson DSO, JP. The service and ceremony commenced at three o'clock on 3 April 1921 and was watched by an estimated crowd of 5,000. The monument, made of Glencoe granite, was the work of Mr G.D. Pape, the local stonemason. After the sounding of the Last Post, followed by two minutes silence, the dedication ceremony was performed by the Revd W.E. Varah.

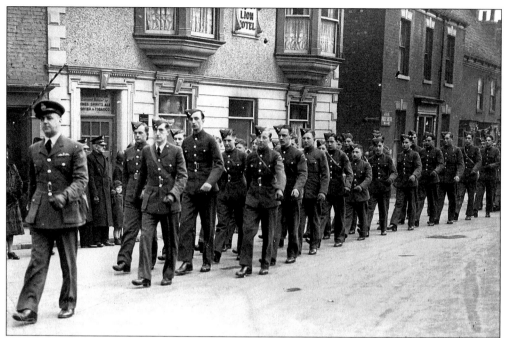

Barton Air Training Corps, 1941. Members of the squadron are marching through Junction Square probably during 'Wings Week' when money was raised to build more Spitfires. The men are led by Flying Officer Eric Batchelor, manager of the local cement works, followed by Freddie Manning (wearing spectacles). The tall man behind him is Arthur Knight. Leading the outer column is J. Brameld, then, left to right: ? Jennings, R. Bingley, -?-, A. Thompson, B. Straw, A. Beedham, W. Paul, G. Lindley, J. Grimoldby, J. Foster.

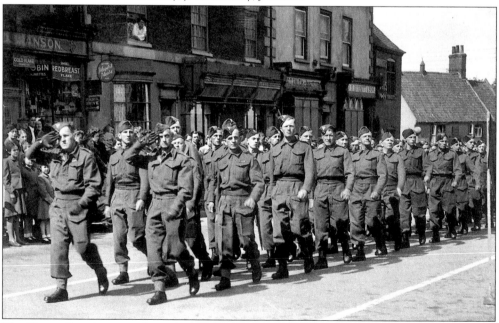

The Home Guard on parade in the Market Place during the Second World War. Lt Officers Windross (left) and W. Robinson (right) salute their superiors at a march past.

Four
Trades and Industry

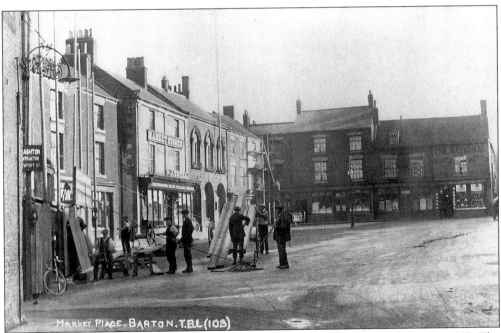

Workmen from Henry Ashton busily erecting scaffolding in Barton Market Place in 1913. The building they are working on is the new National Provincial Bank whose first manager was to be Charles Stanley Parker. Henry Ashton had his joinery premises in Newport Street with his builder's yard in Finkle Lane. Besides being a building contractor, he advertised himself as a bank, shop and office fitter.

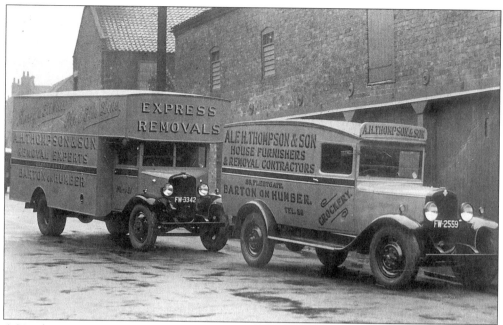

A.H. Thompson and Son, one of the oldest established businesses in Barton, with premises in Fleetgate. In the 1930s, when this superb picture of their vehicles was taken, Alfred Henry Thompson and Son were listed as china, glass, gramophone dealers and haulage contractors at No. 23 Fleetgate, while at Nos 18 and 20 they are noted as house furnishers and furniture removers. This picture was taken in Castledyke West opposite the county school.

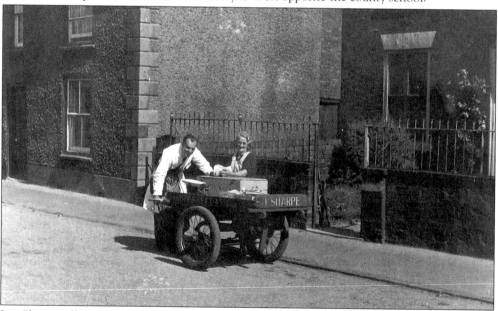

Jim Sharpe selling fish to Mrs Mitchell in Soutergate around 1935. Jim lived in Butts Road but kept his barrow in a shed in the yard of Ashton the builder. Fish was delivered daily from Grimsby and he also did a wonderful trade selling cockles, mussels and prawns, which were all sold by dinner time as there was only one wet fish shop in the town. He ceased trading on the outbreak of the Second World War.

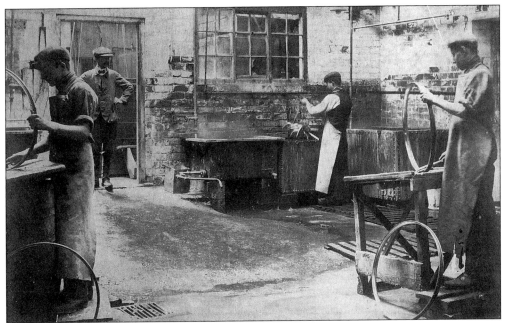

F. Hopper and Co. The year 1880 saw the introduction of bicycles made by 'HOPPER'. The business started in a small workshop on Brigg Road and as it grew larger premises were acquired in Marsh Lane. This picture shows men in the plating shop, with the foreman in the doorway. By 1905, over 400 people were employed by the company.

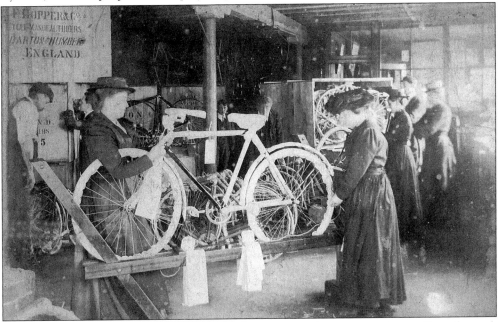

F. Hopper and Co. This early picture shows the wrapping department prior to dispatch, work which was undertaken in Brigg Road by ladies. After careful wrapping, the cycles were dismantled to be skilfully put into special packing cases. The machines had to be packed very tightly as several were dispatched in each case, ready for export all over the world. Cycle manufacture in Barton ceased in the early 1980s.

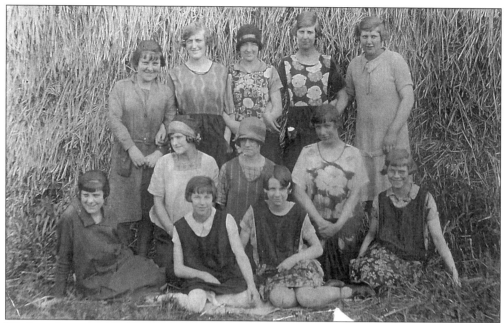

Workers from the Hopper's Wrapping Department on Brigg Road take a break from their endeavours. Smiling for the camera, in the late 1920s are, standing left to right, back row: Hilda Kirkby, Ethel Gouldthorpe, Nora Robinson, Phyllis Robinson, Dorothy Cantrell. Kneeling, middle row: D. Fields, Maud Grassby, Irene Cox. Seated, front row: Maud Kirby, Kathleen Oldridge, Vera Cox, Ethel Beacroft.

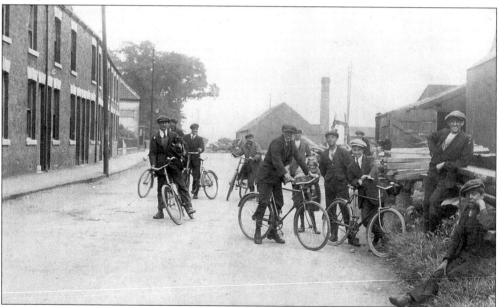

Bicycles, ridden by these men employed at Clapson's boatyard on Waterside Road, were possibly made at Hoppers. Shipbuilding was one of the oldest industries in Barton and this boatyard was started by George Hill in 1846. In 1883 the firm became known as Brown and Clapson, but by 1912 the name was Clapson and Sons. The last boat was built here in 1974, after which the business was transferred to South Ferriby.

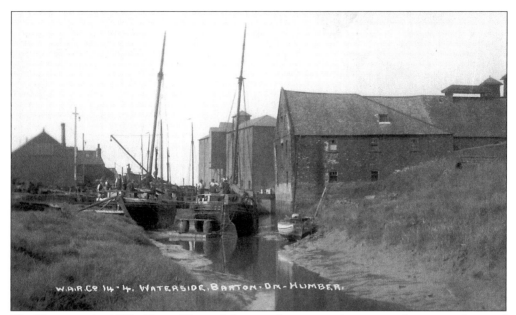

The Haven in the 1920s. Two of Barton's larger industries can be seen on this postcard view of the Haven. On the left men are repairing a sloop, while in the centre is a small pontoon used when tarring the back end of another. It looks a congested, busy waterway. Clapson and Sons shipyard is on the left bank. Opposite, beyond the warehouse, is the malting factory of Gilstrap and Earp of Newark where many local folk were employed.

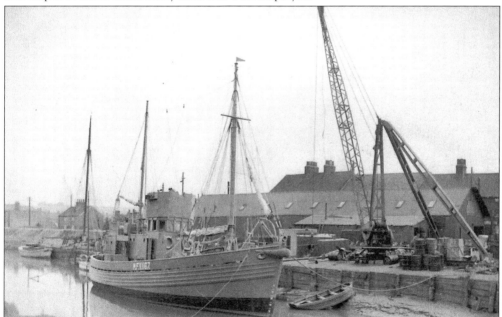

A motor fishing vessel being fitted out at Clapson's shipyard in Barton Haven in the 1940s. In the middle of the picture can be seen the long building in which many boats were constructed. This was a busy yard and during the war, mine-sweepers were built here. By the late 1940s it was capable of building approximately four fishing boats and two private boats per year as well as carrying out repairs.

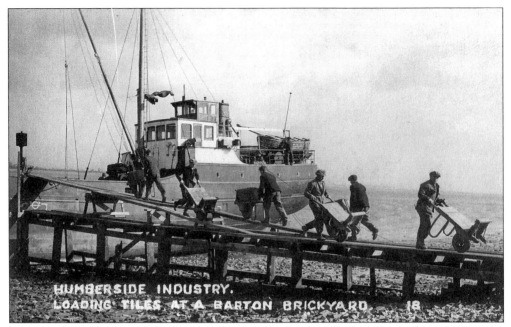

Loading tiles at brick and tile factory, Barton. The brick and tile industry flourished on the Humber bank, with many barges entering the river on high tide loaded with Barton tiles for delivery to many parts of the country. This picture of men loading tiles provides pleasant memories of a time when this mode of transport was commonplace. Tile making still goes on at Barton, but river transport has been superseded by road haulage.

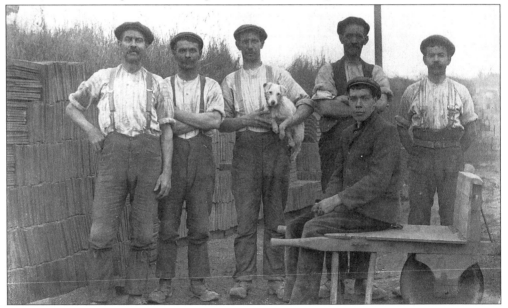

Some of Barton's tile and brickyard workers. Brick and tile-making was an important source of employment with land adjoining the Humber providing excellent clay. Clay was usually dug in the winter when it was wet, and bricks were made in the summer. Pictured in front of a stack of tiles are, left to right: Billy Hare, Walt Hare, Albert Hare, George Hair, Tom Green, with John Nickerson on the barrow.

58

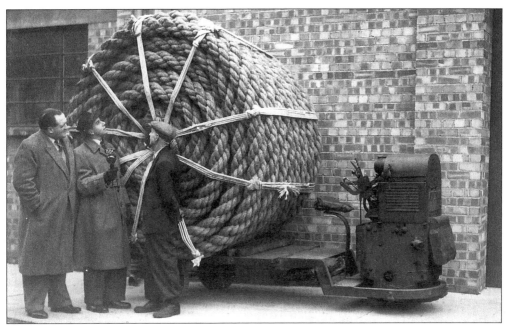

Hall's Barton Ropery. Richard Dimbleby is interviewing one of the workmen when BBC Radio visited for the programme *Down Your Way*. Ropemaking was a cottage industry in Barton in the eighteenth century until John Hall, master mariner, merchant and ship owner, purchased the ropery near the Haven in 1800 to supply his own ships. The ropeworks grew rapidly and became one of Barton's major employers. In the face of adverse trading conditions and competition, it closed in 1989.

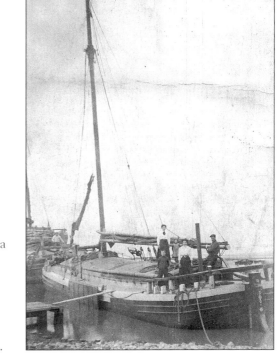

A sloop moored at one of Barton's jetties, a sight no longer seen commercially. The boat belonged to the East family, and Skipper East is at the tiller. This form of transport was used by the many trades in town, particularly those situated close to the Humber bank, as the Haven was navigable as far as Barton's railway station.

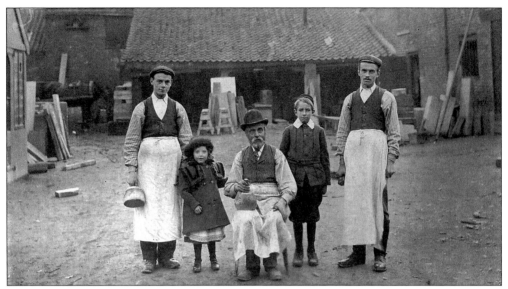

The stone and monumental mason's yard at No. 19 High Street, Barton, at the turn of the twentieth century. It was bought by Mr William King in 1874 and pictured here are William in the centre, with his sons, George Herbert and George William, and his grandchildren, Vera and Donald. The business closed in the 1950s, but the yard remains. Cottage Lane is to the left and Chapel Lane to the rear.

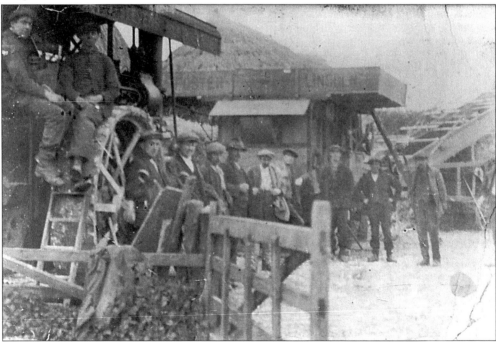

Chapel Farm, 1927. Agriculture provided work at this time for many men and women on the numerous farms surrounding the town and harvest time was a particularly busy period. Pictured on the traction engine are Harold Cotton (left) and Harold Hebblewhite (right). Standing in front of the threshing set are, from left to right: Tom Altoft, Bob Richardson, Ted King, Frank Atkinson, Walt Tuplin, Alf Conman, Frank Proudlove, ? Doughty, ? Howson.

Five
Recreational Time

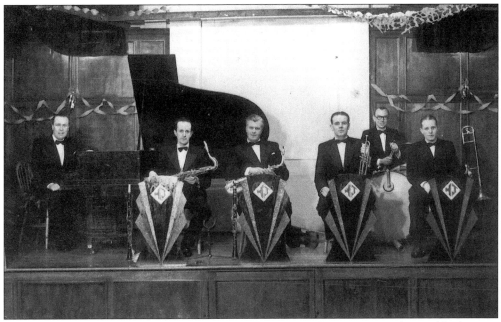

One of the halls in Barton used for dances was the Drill Hall on Butts Road. Harold Johnson's band was very popular with the locals and here they are ready to provide the music for a dance in 1950. Left to right: Harold Johnson (piano), Digby Etty and Clary West (saxophone), Arthur Teesdale (trumpet), Jimmy Lancaster (drums), Bill Crowther (trombone).

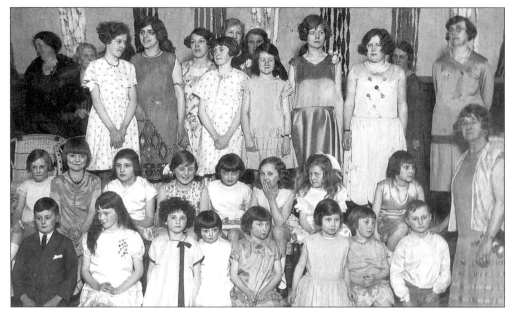

Ballroom dancing in the Assembly Rooms where Miss Lena Welsh had a class. She taught the Polka, Veleta and other dances to these young pupils, who entertained their parents once a year: the 'event' of the social calendar. Miss Welsh is standing bottom right. Posing for their photograph, the children of 1930 are, left to right, front row: Bob Rickwood, ? Stewart, -?-, Lois Burton, Barbara Robinson, ? Dent, Ivy Pape, ? King. Middle row: -?-, -?-, Joyce Rook, Mary Temple, Hilda Robinson, Sheila Barraclough, Faith Atkinson, -?-. Back row: -?-, -?-, ? Toogood, -?-, Margaret Altoft, ? Dore, ? Wright, and an unknown pianist.

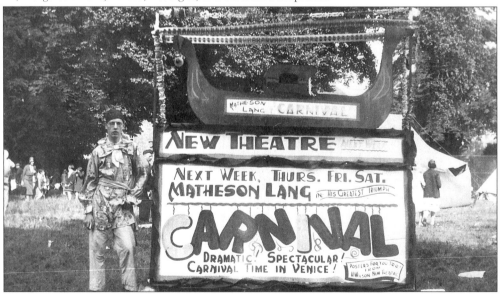

The New Theatre, Oddfellows Hall, on the High Street. The theatre, where films were shown, was owned by Mr H. Wilson. This is an advertisement for the film *Carnival*, pictured in August 1932. It is probably in Baysgarth Park at the time of Barton's Carnival. Barton Amateur Dramatic Society also presented their plays at the New Theatre but they disbanded on the outbreak of war in 1939.

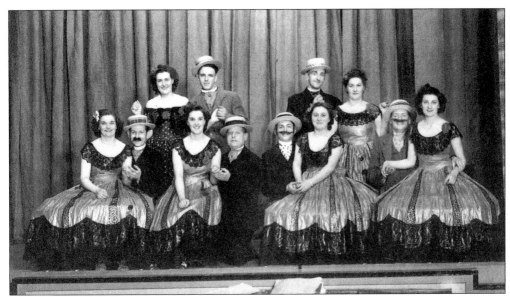

Barton Amateur Theatrical Society, formed 1946/7 by Mr Stanley Clark, based initially around Barton Young Conservatives. It staged musical revues and one pantomime during its existence of about ten years, commencing with *Fast and Furious* in April 1948. In a scene from one of the productions are, left to right, back row: Peggy Gouldthorpe, Arthur Field, Stanley Clark, Hazel Else. Front row: Jean Parrot, Pat Ashley, Grace Ellis, Jack Ashley, Raymond Waltham, Nora Stephenson, Jack Foster, Marie Atkinson.

Another scene from a production by Barton Amateur Dramatic Society. Stanley Clark, a local newsagent who trained as an accountant, not only produced the show, but wrote most of the material. In this lightning cameo scene, Stanley Clark, the husband, is having his palm read by Margaret Atkinson, to be told his wife is pregnant, causing him to splutter. If the baby is a girl the mother will die, if it is a boy the father will die. The steward, played by Jack Foster, falls dead!

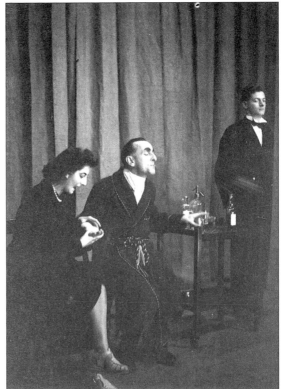

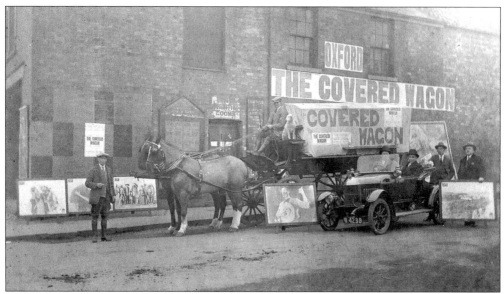

A wonderful advertisement for the film *The Covered Wagon* shown for a full week at the Oxford Cinema, *c.* 1930. Normally two films were shown each week, but this film was billed as a gigantic attraction. Sid Haxley is seen here driving the covered wagon around the town, when Cecil Whiteley was the owner of the Oxford and Ethel Beacroft worked in the box office. The cinema, situated in Newport, closed in 1972 and is now a fitness club.

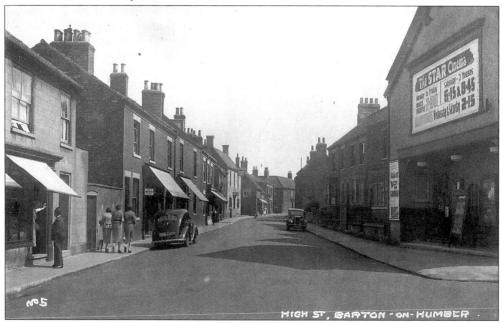

The Star Cinema in the late 1930s. This smaller of the two cinemas in Barton was also owned by Cecil Whiteley, and known affectionately as the Ranch by local people because of the number of Westerns shown there. The cinema, on the corner of High Street and Fleetgate, closed in the late 1950s and the site is now unoccupied but had been converted into a supermarket in 1963. Cinemas were in their heyday at the time of this picture and were packed to capacity, before the advent of television.

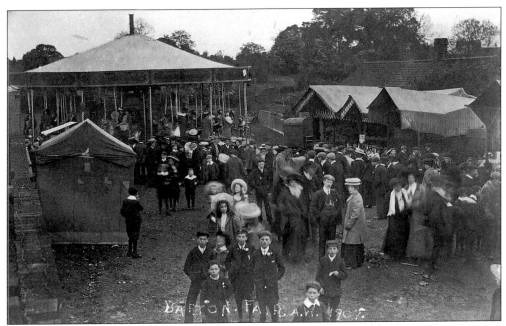

Barton Fair, 1907. Children and adults alike enjoyed the attractions of the fair on Brigg Road in the paddock belonging to the George Hotel. Still held in June each year, the fair is now to be found on the Marsh Lane football ground since this paddock was acquired for building. It is known today as Beretun Green.

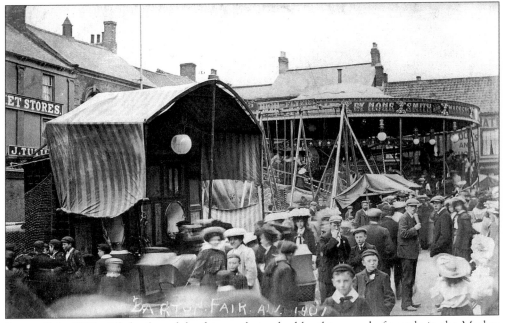

Barton Fair, 1907. All the fun of the fair was being had by this crowd of people in the Market Place. Smith and Warren of Lincoln, whose gondola ride can be seen here, were familiar names in the district as they visited all the town and village fairs. It is said that the fairground organ was used at Barton for an outside service on Sunday, with a collection being taken for the church.

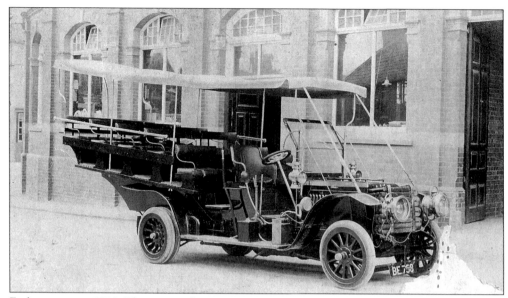

Early motoring, 1913. This postcard was sent to Henry Barton, fruiterer, High Street, Wainfleet All Saints in 1913 from his son Jack, concerning his new sensation. The message reads 'This is the car I came through with, it will carry twenty-four, the same as I took you to Skegness with, but we have had it altered and a new body and wheels fitted to it. It is a big thing and causes a sensation wherever we go.' The picture was taken by Arthur Brummitt outside Hopper's offices in Brigg Road.

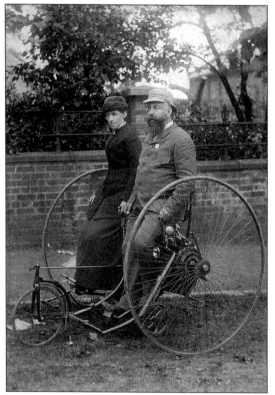

A bicycle, known as the sociable. Mr and Mrs William Jackson travelled quite a lot on this quaint bicycle and this marvellous machine must also have caused a stir when seen in Victorian Barton. Mr Jackson was the first headmaster of the Wesleyan Day School in Maltby Lane and Mrs Jackson was the assistant mistress. They spent their retirement days at Hessle.

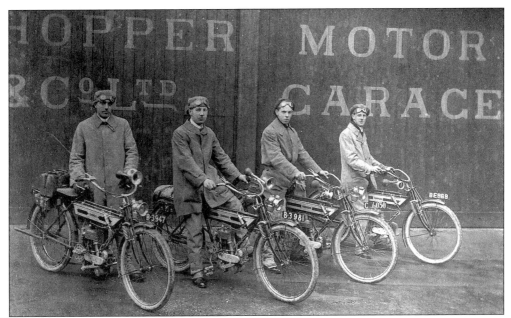

An enthusiastic quartet of motorcyclists about to set off from Hopper's garage. Motorcycling became an enjoyable pastime in the early years of the century with many thriving motorcycle clubs. F. Hopper and Co. extended their business in 1904 to include motorcycles, however they were only produced for a short time. More motorcycles were produced in 1923 but again production was short lived.

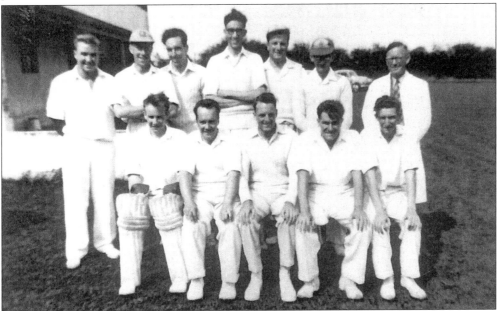

Barton Town Cricket Club, one of the oldest clubs in Lincolnshire, is still in existence. Founded in 1849, it is in the enviable position of owning its own ground on Marsh Lane. This Barton team, all smiles, is ready for a match and is pictured in front of the pavilion in 1956. Left to right, back row: J. Kirk, J. Brice, E. Hall, R. Sparks, R. Chapman, J. Tauton, Tom Hill (umpire). Front row: J. Eayres, H. Allenby, D. Lawson, B. Creasey, C. Burnett.

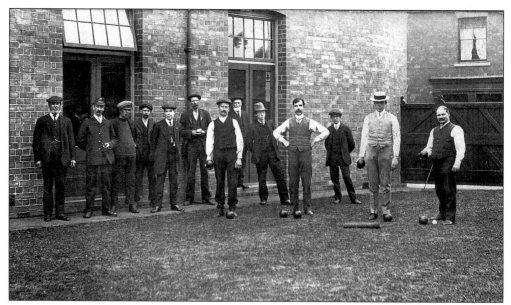

A game of bowls on the green at the Liberal Club, now known as the Queen's Club. Queen Street can be seen behind the gates at the right of the picture. Mr Overton Wass, a grocer, draper and outfitter of Newport Stores is on the extreme right of the group. Mr Matthews, a postman, is wearing a trilby hat. A car park for the club occupies the site of the bowling green today.

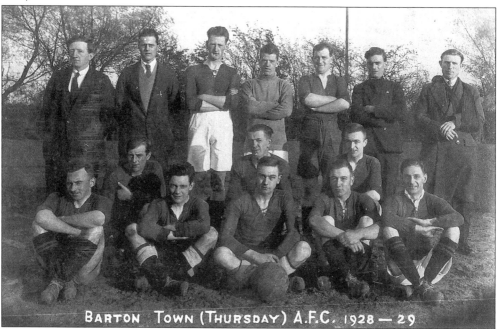

Barton Town Thursday AFC, 1928/9 season. This team consisted of Barton businessmen who played on a Thursday afternoon on the Marsh Lane football ground. Pictured before a game are, left to right, back row: ? Matthews, ? Lindley, ? Mills, -?-, Fred Bingley, -?-, Jack Stone (referee). Middle row: -?-, ? Houghton, ? Lacey. Front row: Jack Whitehead, Gilbert Toogood, Don Lacey, Ernie Lacey, Bill Robinson.

Six
Sundays
and Schooldays

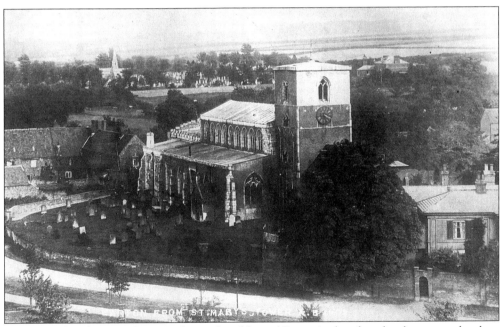

St Peter's church, around 1905. This is the oldest of Barton's churches, but became redundant in 1971 with all services transferred to St Mary's. To the right of the tower is the old vicarage where Dr Chad Varah, founder of the Samaritans, was born. To the left is Tyrwhitt Hall, named after a family who lived here in the sixteenth century. This view was taken by Arthur Brummitt from St Mary's tower.

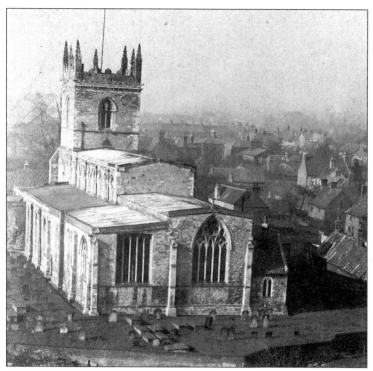

St Mary's church in the early twentieth century. It is uncertain why Barton has two fine churches so close together: one theory is that the wealthy merchants wished to have a church of their own to worship in. St Mary's is a magnificent church which was started in the twelfth century. This photograph was taken from St Peter's by Arthur West of Barrow. The old part of Soutergate can be seen to the right of the church.

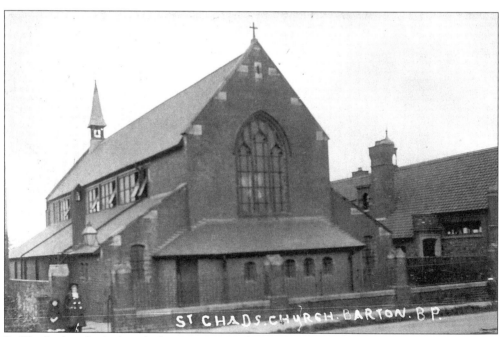

St Chad's church. A chapel of ease in Waterside Road, St Chad's was built in 1903 at a cost of £1,850. Next to it is the church school which was used as a Mission church until the new church was built. Both these buildings have now been demolished. Bartonians certainly had a good choice of churches in which to worship and it has been heard said by the older generation, that when children they went round them for a change.

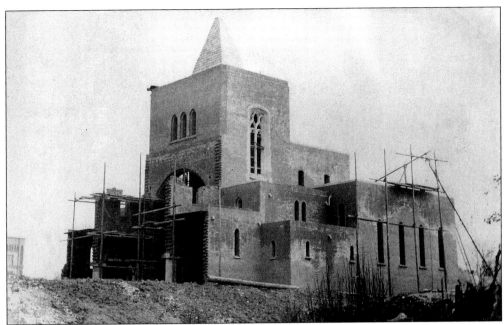

Catholic church, 1938. Construction work in progress on the new church at the corner of Whitecross Street and Barrow Road, with the local firm of Stamp and Son as the main contractor. Dedicated to St Augustine Webster, the new church replaced the one in Priestgate, but this building has in its turn, been recently replaced by a new church on the same site.

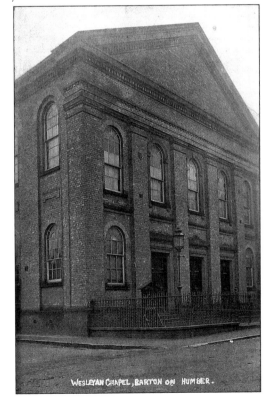

Wesleyan chapel, 1922. It was built in 1863 on the site of a previous little chapel, at the corner of Chapel Lane and Vestry Lane. The fact that it could seat 1,000 people indicates the strength of Methodism in Barton at that time. This fine Victorian building, one of many in the town, is still in use by the Methodist church.

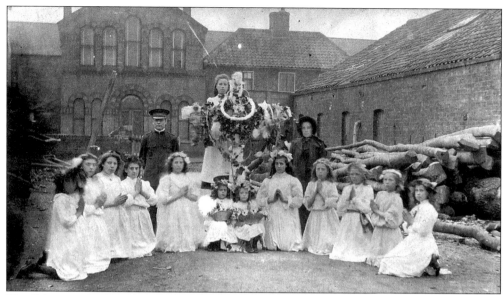

The Salvation Army. The movement has long had a presence in Barton and it is thought their original barracks were in Hungate, moving to the Wesleyan school in Maltby Lane on its closure, and then to their present location (see below). Here we can see a group of children from the Salvation Army carrying out a biblical enactment on the old paddock, Brigg Road. In the background is St Matthew's Lodge of Free Masons and Hopper's original buildings are to the right of the logs.

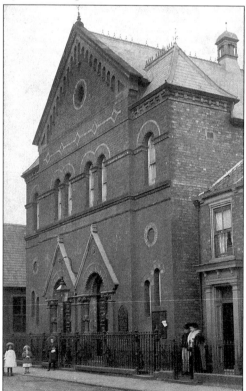

Primitive Methodist church, early in the twentieth century. This picture was issued as a postcard, and the writer states, 'When I preached on 18 July, Chapel Anniversary, we had large congregations. They have a beautiful pipe organ and a good choir. It is a fine church.' The church was built in 1867 in Queen Street and could seat 600 people. This early twentieth-century photograph shows an impressive building with the caretaker's house to the right. It ceased to be used as a Methodist chapel in 1961, but worship still continues here as it is now the Salvation Army Citadel.

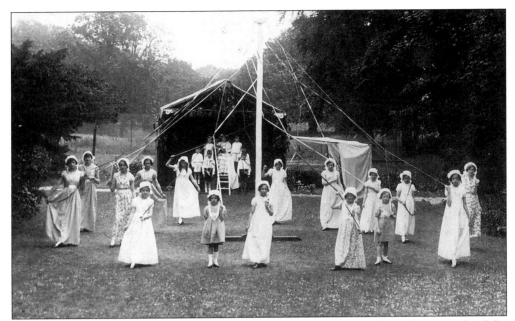

The pupils of Bardney Hall convent school dancing around a maypole in the grounds of the school around 1932. Rosina Ellis, the May Queen, is in the tent at the rear with her retinue. Hilda Robinson is to the right of the maypole and Winifred Harrison to the left at the back of the group. The Convent of Our Lady and St Oswald opened in 1928 for both day and boarding, closing in 1950. Bardney Hall, situated in Whitecross Street, has since reverted to a private residence.

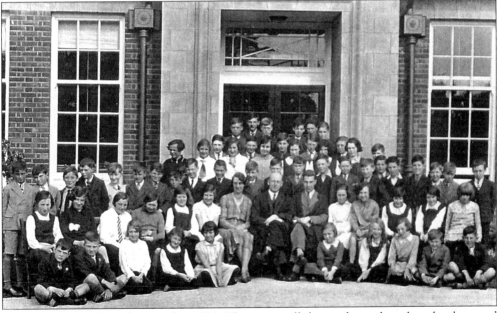

Barton Grammar School, opened in 1931. These were all the teachers when the school opened its doors to sixty-three children in the September of that year. The headmaster, Mr H. Boulton, is in the centre with senior assistant mistress, Miss M.C. Nightingale, and French teacher, Mr N.G. Brice, at either side. They were soon joined by Mrs Davison (art), Mrs Hendry (PT) and Dr Rowbottom (music).

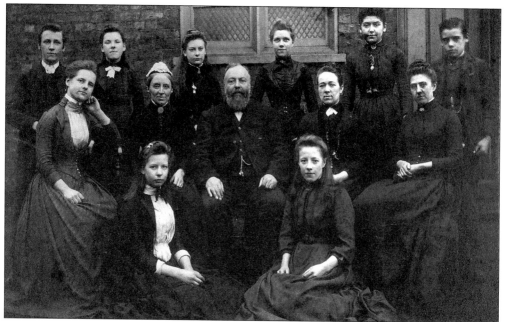

Wesleyan day school in the 1880s. This is a typically posed picture showing the school staff which included Mr William Jackson, the headmaster, and his wife, wearing the white cap. The school was erected in Maltby Lane and opened in 1866 to cater for 473 children, but the average attendance was 480 by 1876.

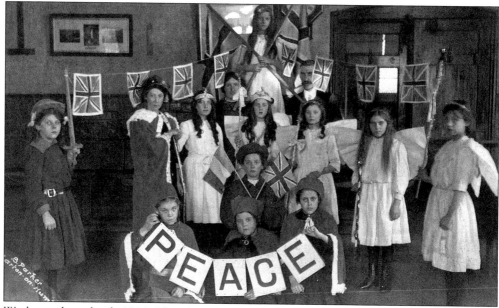

Wesleyan day school, 1914. This shows the last act in this school, 23 December 1914. The average attendance had fallen to 400. Here, Arthur Loughborough joined some of his pupils for a final photograph. R. Barraclough is the fairy holding two flags, N. Wade, F. Furniss and C. Codd are holding the Peace sign. The other pupils are, from left to right: D. Dickinson, E. Espin, P. Patterson, W. Patterson, D. Polwin, N. Ward, H. Smith, N. Havercroft. All the staff transferred to the new council school in Castledyke, which claimed to be the most up to date in Lindsey.

Seven

Barrow
and New Holland

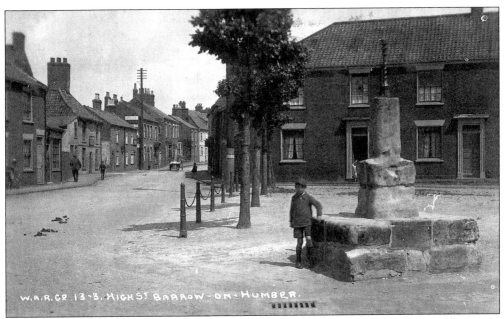

W.A.R.C? 13·3. HIGH S? BARROW-ON-HUMBER.

The large village of Barrow, three miles east of Barton-upon-Humber in the 1930s. The stocks stones remain a prominent feature of the Market Place today. On one side was a hollowed-out seat where wrongdoers were made to sit as a punishment, or so the story goes. Looking down the High Street is the shop of William Staveley, the grocer, just past the Red Lion Inn. Further on is Nellie Brumpton's paper shop where Nutty Shepperson used to cut hair in the back room.

Local volunteers gather in Barrow Market Place in front of the stocks stones during the Second World War, ready to do their bit. Left to right, back row: Mrs Hall, Cyril Woolley, Marie Hall, Billy Duffill, Nora Bramley, Clara King, Mrs Sanderson. Front row: E. Poulton, Harry Foster, Alf Houghton, Ella Cherry, May Schofield, Mr Vokes, George Stamp, Nurse Ward, Major Sanderson, Dick Duffill.

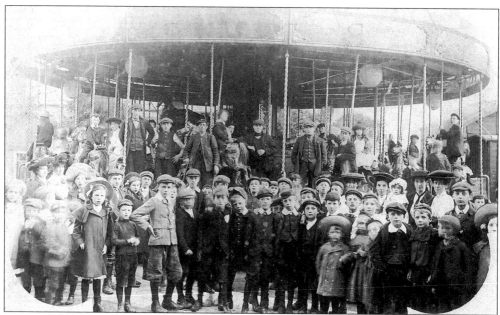

Barrow Fair in the very early 1900s. The fair was held annually on 11 October and, as this photograph taken by Arthur West shows, there were plenty of local children eager for a bit of fun: the photographer has clearly aroused their interest. This fair, not a particularly large one, was usually sited in the Market Place. The steam horses belonged to Smith and Warren.

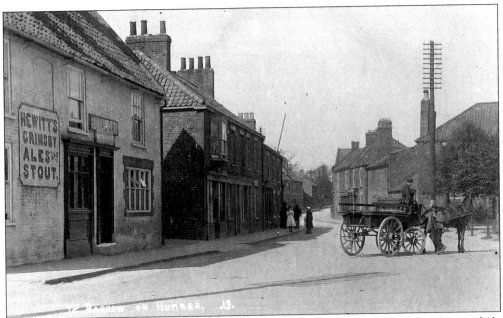

A waggonette, possibly Joseph Clark's, in the Market Place during the 1920s. He ran daily services to and from New Holland to meet the ferries, as well as having a grocery shop in the village. At this time The Royal Oak was kept by Robert Hagar. Next door was Sarah Parkin's fruit shop. She also made her own homemade ice cream: a penny for a cornet, tuppence for a wafer.

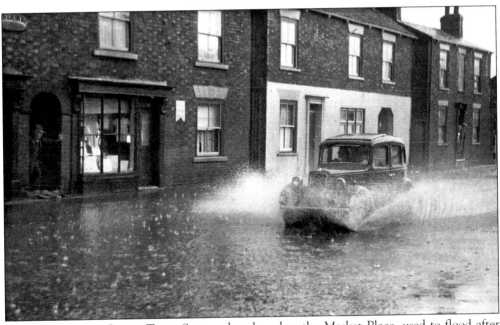

Flooding in Town Street. Town Street, also classed as the Market Place, used to flood after heavy rain because of the lack of adequate drainage. This Austin Seven ploughs through the water, watched by Mr Hallam, the painter, decorator and local bandsman, who is standing in the passageway. The shop is Miss Tasker's drapery store.

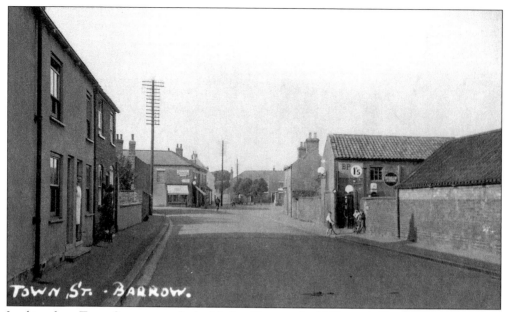

Looking from Town Street towards the Market Place in the 1930s, with Hugh Bilton's garage to the right. His petrol cost 1/5d per gallon from pumps worked by hand. Beyond the garage is Joe Hewitt's grocery shop. The houses to the left, where a lady is busy cleaning the windows, were bombed during the Second World War, and have since been replaced by a bungalow. George Tong's shop is on the next corner, later to become Frank Wardell's garage.

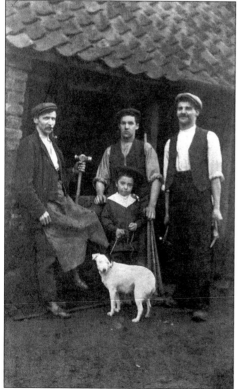

An early photograph of Arthur Richardson, the blacksmith, with two of his sons and a daughter, outside the smithy in Silver Street. Arthur is smoking a pipe, Fred is in the centre with Harry next to him, and the little girl is thought to be Dorothy. Arthur's son, Wilf, worked on the woodwork of the wagons. This was one of two blacksmiths' shops in the village; the other was in Green Lane.

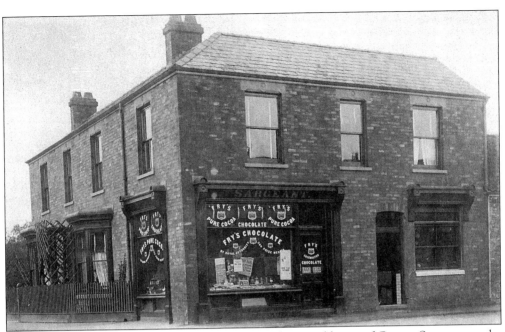

Another picture by Arthur West featuring the two shops and house of George Sargeant on the corner of Silver Street and Thornton Street. Folk could buy their meat from his butcher's shop on the extreme right, while those with a sweet tooth were catered for at his confectionery business. The whole of this property is now a private house.

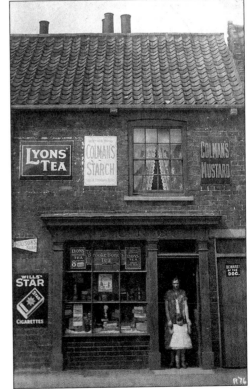

Alice Tong at the doorway of her grocer's shop in Silver Street, with daughter Pearl. In June 1942 her husband, Jim, was out fire-watching when a landmine, on a parachute, fell on the building and destroyed it killing both Mrs Tong and her daughter. Bramley's livery stables, to the left of the shop, were also destroyed in the explosion.

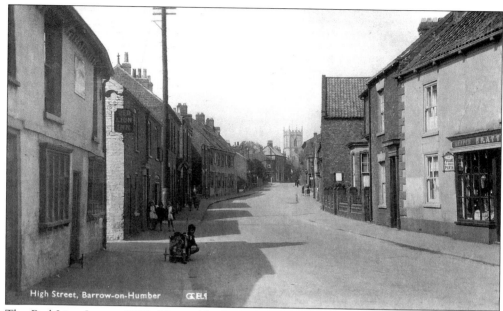

High Street, Barrow-on-Humber

The Red Lion Inn, *c.* 1930. This public house can no longer be seen in the High Street as, following closure, it was eventually demolished after the Second World War. Frank Clayton was the final landlord in the late 1920s and this postcard view is from soon afterwards. Midway on the left is the Papist Hall where the Roman Catholics used to meet; it has now been converted to luxury flats. Opposite is the Methodist chapel, first built in 1833, which has become the Village Hall. Today, Bratton's drapery store is a hairdressing salon.

Looking back towards the Market Place, *c.* 1920. The post office is on the left, where James Metham, the postmaster, also sold groceries. Behind the railings to the right is Ribston House. The little shop further on has had many uses including that of a bank, a facility which, alas, no longer exists in Barrow. The Papist Hall can again be seen, it belonged to Percy Camm whose house is next to the shop.

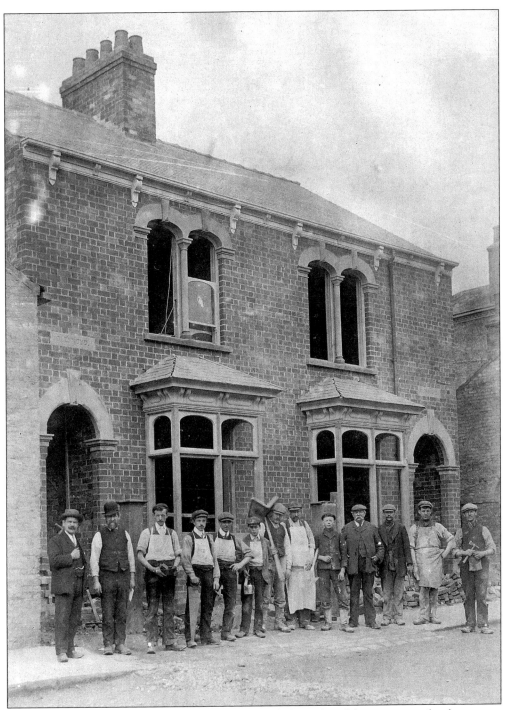

Bricklayers, joiners and other craftsmen take a break from their labours to pose for the camera in High Street. This pair of houses were under construction just after the First World War, for the Camm family and were called Glenroyd and Glenholme. Percy Camm was to live at Glenholme, while Glenroyd was leased. At one time it was occupied by Mr Metham, son of the postmaster.

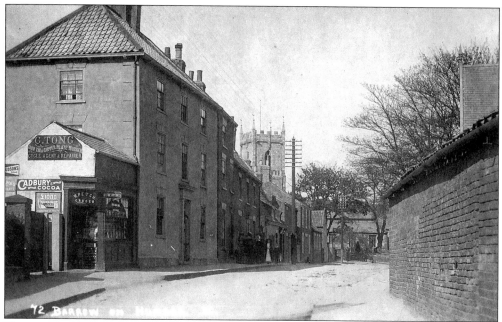

The grocery shop of Walter Petch in the 1920s. Today, Chapmans have this grocery and off licence, though it has been much enlarged since Walter Petch was in business here. An advert for George Tong, cycle agent and repairer, is prominent on the wall. Mr Tong's premises were closer to the Market Place, where he also sold radios, and is said to have had the first petrol pumps in Barrow, which were situated on the footpath outside. Holy Trinity church can be seen in the distance.

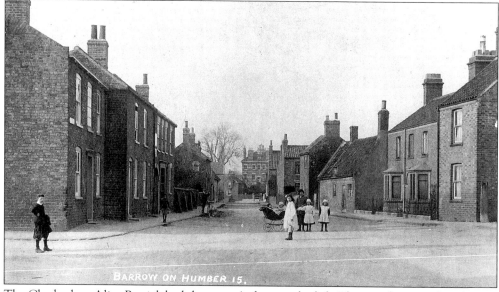

The Chad, when Alice Barrick had the grocer's shop on the left. This area has seen few changes since the First World War. The shop has been a private house since the 1970s and, across the street, the little cottage behind the children has been pulled down. In the distance is Down Hall, the home of the Beeton family. Mr Beeton owned the local osier beds, the willow from which was used for basket making by Mr Ernest Barrick up until the Second World War.

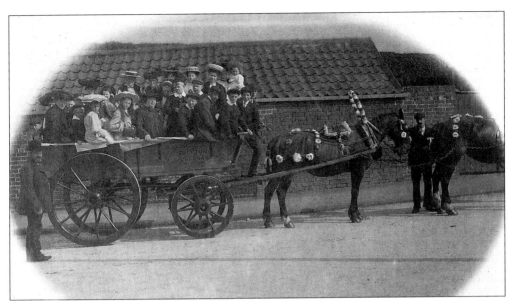

Sunday school children going on an outing to Cleethorpes in the 1900s. In the early years of the twentieth century, holidays were unknown, and the highlight of the year for the local children, was the Sunday school outing to Cleethorpes. The wagons were decorated, and the horses furbished with face brasses, bell topping, and trimmed with a variety of bright colours. Here we can see children in one of Mr Beeton's wagons, probably on their way to Goxhill station. After the General Strike in 1926, trains were no longer used and buses became the favoured method of transport.

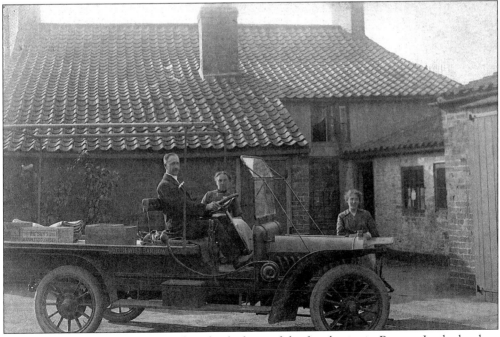

Sandpit Farm with Joe Hewitt at the wheel of one of the first lorries in Barrow. Joe had a shop in Town Street (see p. 78), which was later used as a library. Among the items for delivery to the farm are Colman's Starch, Watson's Matchless Cleanser and Sunlight Soap.

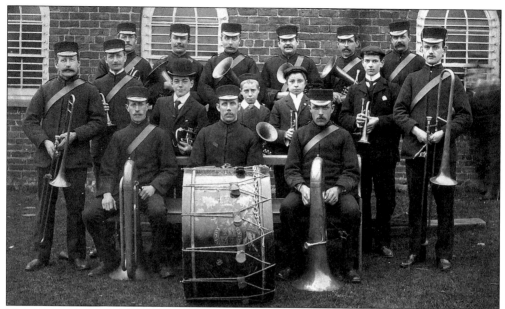

The Barrow Britannia Band posing for an official photograph at the rear of the Primitive Methodist chapel around 1917. Left to right, back row: Mr Briglow, J. Bell, W. Smith, C. Osgerby, C. Dawson, Mr Petch. Middle row: H. Hallam, J. Bramley, Chas Osgerby, Mr Briglow Jnr, W. Peart, M. Towle, G. Borrill. Front row: Wm. Barton, R. Hornsby, H. Topps.

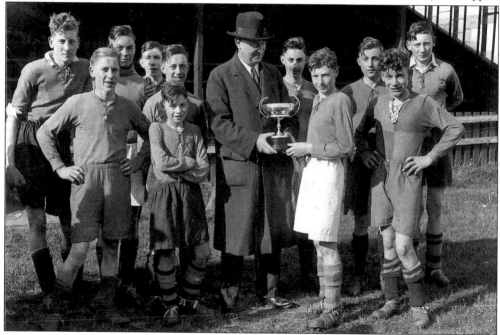

The cup being presented by Councillor Barraclough to Jack Foster, captain of Barrow Boys FC in 1939. The venue for this match was Barton's pitch at Marsh Lane, but the club, which was run by Bill Petch, usually played at the Playing Fields in Barrow. Left to right, back row: Arthur Jackson, Dennis Adamson, -?-, George Bell, -?-, Jack Spencer, Colin Skelton. Front row: Raymond Bell, Royce Foster, Jack Foster, Ken Harness.

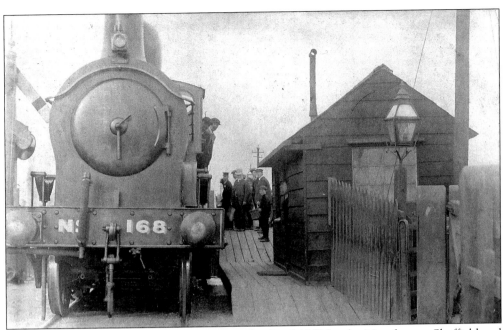

Barrow Haven station. The station was opened 8 April 1850 by the Manchester, Sheffield and Lincoln (MS & L) Railway Company, on the branch line from New Holland to Barton. Built almost two miles south of Barrow, it was a busy little station because of the number of brickyards and shipyards in the vicinity. The children from this small community were collected by horse and cart to attend school in Barrow.

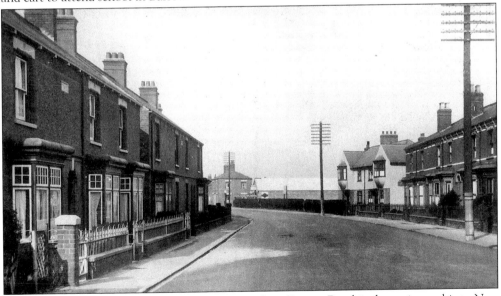

Barrow Road in the late 1920s. As its name implies, Barrow Road is the main road into New Holland from Barrow. Looking towards the railway station and pier, Regents Terrace is on the right, and just discernible is the garage with its white roof, known as Central Garage. The proprietors ran a service for commercial travellers. They would transport the customers in their own cars to the station and ferry, then garage these cars until next morning, when the service was reversed. The garage was full of cars staying overnight.

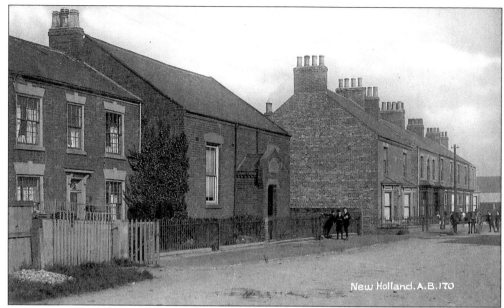

The Wesleyan chapel is in the centre of this row of houses, further down Barrow Road, *c.* 1920. A new organ was installed there in 1905 and the opening ceremony was performed on Sunday 26 February 1905. The following year, a new floor, rostrum and choir seats were put in, and after a short closure the chapel was reopened 22 November 1906 by the Revd Roebuck. It stood almost opposite the Central Garage, but has recently been demolished.

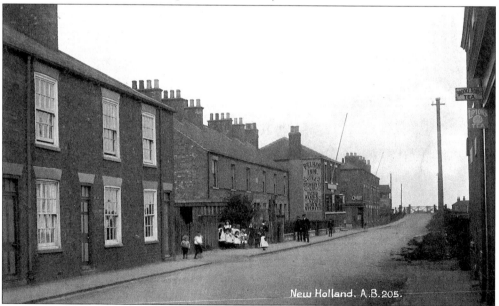

Another view of New Holland in the 1920s. The Pelham Inn is situated on the left of Oxmarsh Lane, when looking towards the railway crossing and its adjacent signal box. In the distance, on the right, Calais Row, a row of twenty-two houses which originally housed the navvies who built New Holland Dock, is just visible. On the corner is Theodore Skinner's general store, where you could buy almost anything. He is remembered for his habit of always wearing breeches and shiny leggings.

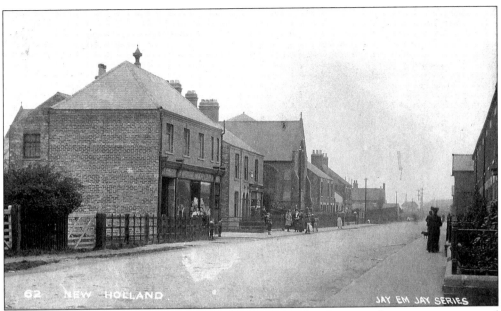

The impressive premises of the Great Grimsby Co-operative Store on the main street, opened on 2 December 1905, not long before this photograph was taken. Whist drives, children's parties and dances were held in a room above the shop which was used rather like a community hall. The parish church, Christ Church, which was erected in 1901 can be seen nearby. Close to the railway is Milo Terrace, named after the first loco that came into New Holland.

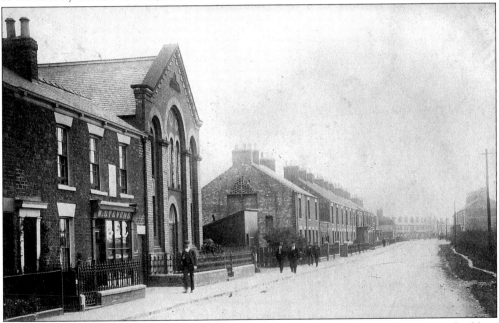

Looking back towards Barrow, *c*. 1905. The Primitive Methodist chapel, an imposing building erected in 1877, can be seen and is still used for worship by the United Methodists. To the left is the shop of Walter Stevens, grocer, whose new shop front was completed on 23 June 1904, and to the right is Arthur Barrett's fried fish shop. This hut was moved there from its site near the Wesleyan chapel on 7 July 1902.

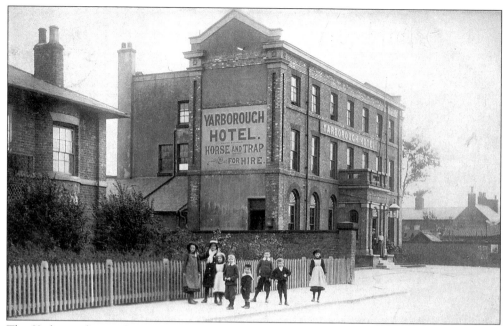

The Yarborough Hotel, situated adjacent to the station and Humber ferry connection with Hull. This hotel was built for the MS & L Railway by William Kirk of Lincoln and was opened in April 1851, having cost £1,825 to construct. It was later renamed the Lincoln Castle, after the paddle steamer, but closed in the 1990s. The house, to the left, which was once occupied by the railway station inspector, Mr Doyle, has been demolished.

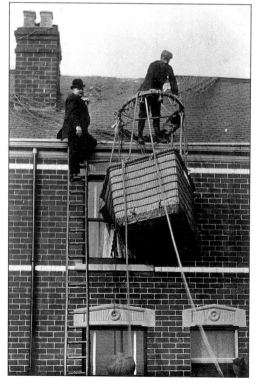

The wrecked *Elfe*, 1906. The Italian balloon *Elfe* was wrecked when it descended onto a house in New Holland, Monday 1 October 1906 while competing in a balloon race. The man wearing the bowler hat is said to be Mr Camm, the joiner from Barrow, the other man is possibly the pilot.

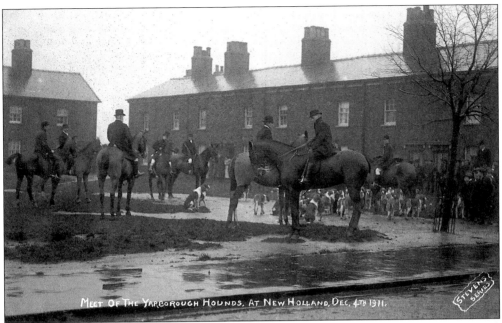

MEET OF THE YARBOROUGH HOUNDS, AT NEW HOLLAND, DEC. 4TH 1911.

STEVENS SERIES

The meet of the Yarborough Hounds at Manchester Square, 4 December 1911. The hunt took place around the countryside of Barrow and New Holland and belonged to the Earl of Yarborough at Brocklesby. Manchester Square, comprised of workers' homes set around a quadrangle, originally belonged to the MS & L Railway Co. – hence the name. The area has recently been regenerated and these houses are now mainly privately owned.

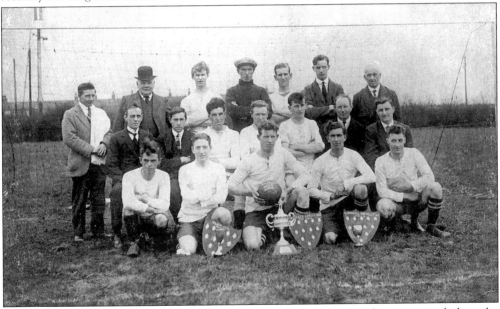

New Holland FC, with the trophies they had won during the 1923/4 season, including the Humber Challenge Cup. They played in a field opposite the Pelham Inn, where an old signal box acted as a pavilion. Mr Bilton, the landlord of the inn, wearing a bowler hat, is on the back row and middle row, third left, is Arthur Turner. Wally Edwards is on the front row, with Mr Bell on the extreme right next to Albert Jackson.

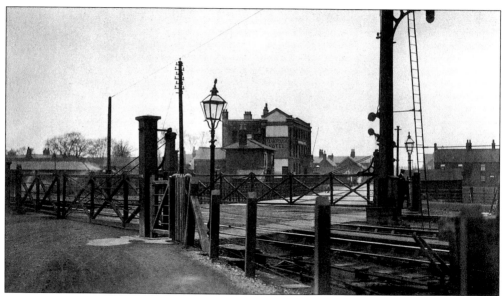

The Barrow Road railway crossing, c. 1913. The Yarborough Hotel is in the centre of the view and the low building to the left is a steam laundry for the railway company which closed in 1931; its manager at this time was John William Stewart. The little hut across the line on the right was built for Mr A. Day who had the first car in the area. He was a Hull businessman who lived in Barrow and used to leave his car in the hut when he went on the ferry to Hull.

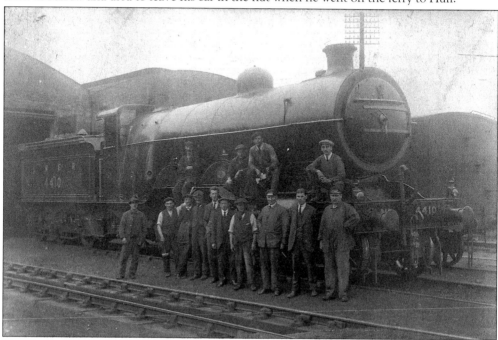

Two locos based at New Holland, c. 1930. They were painted green and travelled as far as Peterborough. They were housed in a loco shed that closed in 1936. Photographed with an Ivatt Atlantic passenger engine No. 4410 are, left to right (on the engine): Fred Akester, Eddie Stainton, Steve Elliot, Gordon Dent. Standing in front: ? Turner, ? Wright, ? Fields, W. Catton, F.G. Reed (chief clerk), C. Bilton, C. Smart, A. Kirman (driver), D. Brewer, A. Todd (driver).

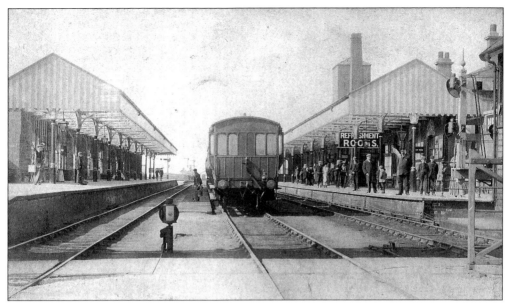

New Holland town station, photographed by Arthur Brummitt of Barton, around 1905. The stationmaster is on the platform, close to the refreshment rooms with crowds of people who have just come from the ferry. The man beside the carriage on the centre line is a carriage cleaner. The town station signal box can just be seen in the right foreground beside the crossing which allowed vehicular access to the ferry. The station was closed after the ferry service stopped in 1981 and has subsequently been demolished.

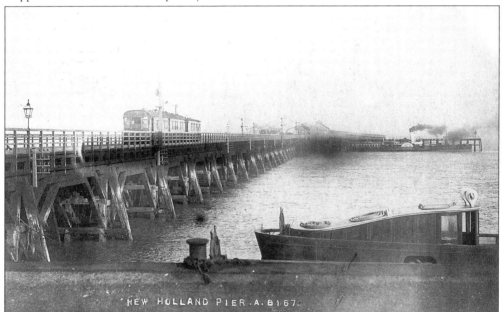

The old pier, built in 1848, from a postcard view sent to Belgium in 1908. It shows a GCR steam rail motor on the pier, with a carriage in tow. New Holland pier station can be seen in the distance, and also the paddle steamer *Cleethorpes* in steam. This vessel was sold in 1934 and went to Leith as a cruise ship. The boat moored at the ferry repair workshops, in the foreground, is probably the *Doncaster*.

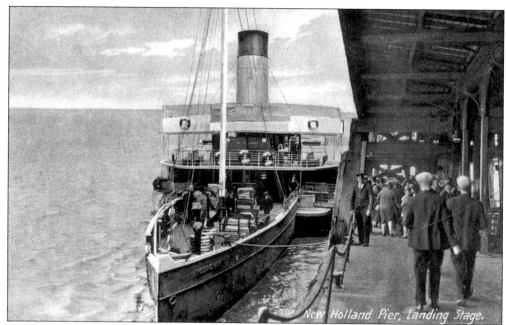

The ferryboat, *Frodingham*, moored at the old pier and loaded with goods for Hull market on the foredeck, *c.* 1930. Passengers wait on the wooden slope to embark. During 1922, twenty-two bays on the pier were renewed at a cost of £39,240. The *Frodingham* was built in 1918 and originally named the *Dandy Dinmont*. It came to New Holland in 1928, and was in use on the Hull service until 1936.

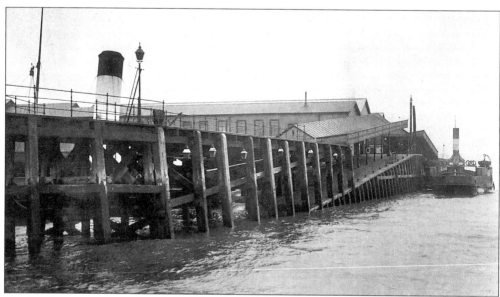

The landing stage, seen from the River Humber, with the old landing slopes clearly visible, around 1912. The bell on top of the post near the ferry boat was tolled when the boat was about to sail and was also used in foggy conditions. New floating stages with hinged ramps were begun at New Holland in 1935 and completed in July 1938 at a total cost of £55,700. The western slope was renewed in 1948.

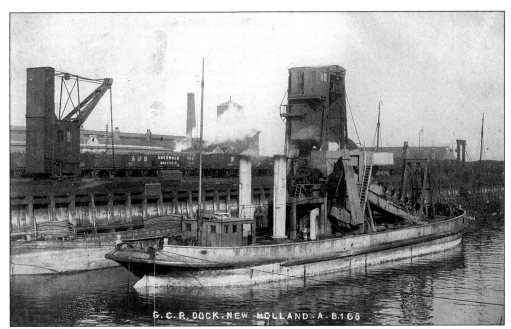

A bucket dredger in the Great Central Railway dock in the early 1900s. Also in this view is the 12 ton crane on the left, which was used to load lighters. A coal hoist, seen just above the dredger, was used to 'coal' all the tugs belonging to the United Towing Co. of Hull. The docks are no longer owned by the railway, but are still in use, mainly by Howarth Timber.

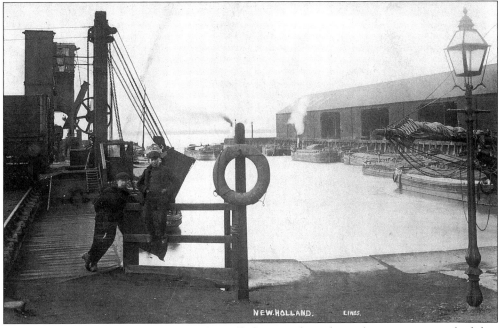

A very busy scene in the dock showing lots of lighters to the right, and a tug in steam, which has no doubt brought them across the river from Hull. The contents of the wagon, to the left, are to be transferred into the hoist and then into the awaiting boat. Gas, used to light the lamps on the pier and dock, was generated in the gashouse on the site.

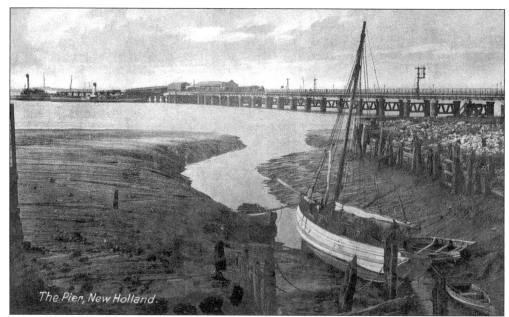

The Pier, New Holland.

A Yorkshire cobble named *Diana* in the foreground, moored at Dent's Creek. It was owned by Joe Kirk, a ferryboat skipper who was reputedly the finest skipper ever to sail the Humber. A legend in his own lifetime, he knew the river like the back of his hand. When he was off duty, his hobby was fishing and his catch would include shrimps which he used to boil in a copper before selling them on the dock. The new pier can be seen in the background.

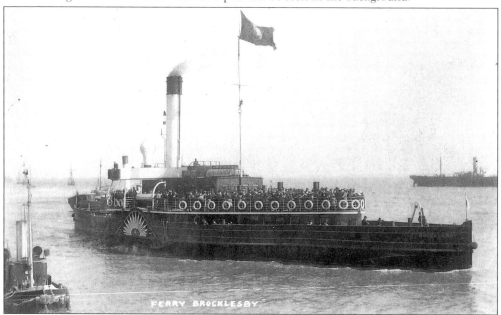

FERRY BROCKLESBY.

The ferryboat *Brocklesby*, built at Earle's shipyard at Hull in 1911 for the G.C. Railway Company. She operated between New Holland and Hull until 1935/6 when replaced by the *Wingfield Castle* and *Tattershall Castle*. The *Lincoln Castle* came into service in 1940. After being sold to a shipping company, the *Brocklesby* went to Leith, was renamed the *Highland Queen*, and was used for cruising the Firth of Forth.

Eight

Goxhill
and Thornton Curtis

Howe Lane, the main street when coming into Goxhill village centre from Barrow. The horse chestnut trees in the distance were planted in front of New Hall by Ken Sarjantson's grandfather. Looking towards the railway station, the signal box is just visible on the extreme right of this picture.

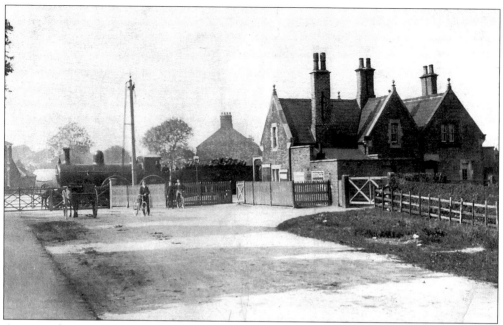

A man with a pony and trap waits at the crossing gates of Goxhill station, on his way out of the village, c. 1905. This station was built in 1848 on the New Holland line and its situation in the centre of the village is quite unusual as most stations were built some distance away. The design is typical of stations on the line. The station house is now in private ownership, with a shelter provided for passengers.

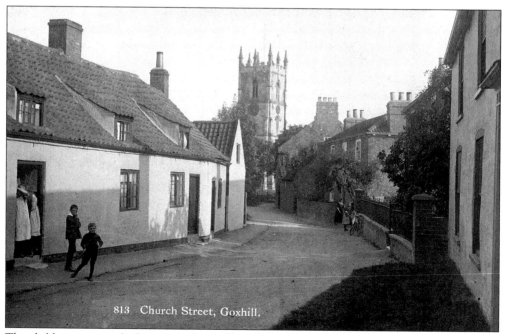

813 Church Street, Goxhill.

The children appear a little camera-shy in Church Street, c. 1915. The three little whitewashed cottages have since been made into one residence, but the view is remarkably similar today. The parish church of All Saints is in the distance at the end of the cul-de-sac.

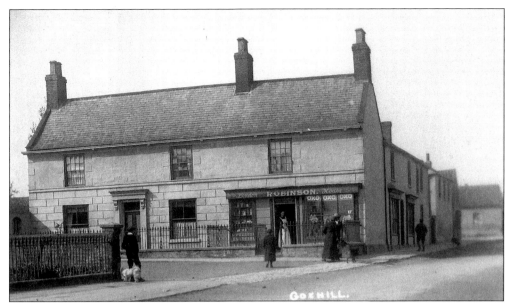

London House, on the corner of Howe Lane and King Street. This is one of only a few shops in Goxhill to survive the passage of time. Eighty or more years have passed since the villagers seen here, made their way to their local store. John Robinson ran a grocery and drapery business, nowadays it is an outlet for newspapers and flowers, owned by Mr and Mrs Giles.

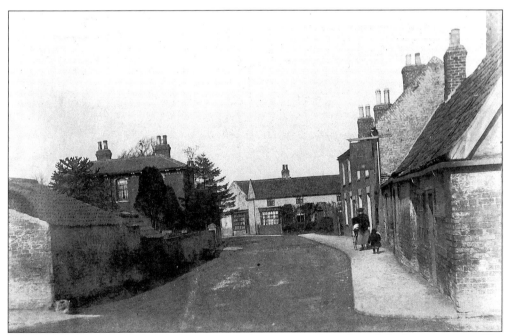

Westfield Road, c. 1905. A faded, swinging pub sign reminds readers of the long gone inn, The Royal Oak in Westfield Road, when William Stamp was the landlord. The still familiar shop front in the distance at this time was a grocery and drapery store with the name of George William Brown above it. Today, a garage stands on the site of the old cobbler's shop to be seen in the right foreground.

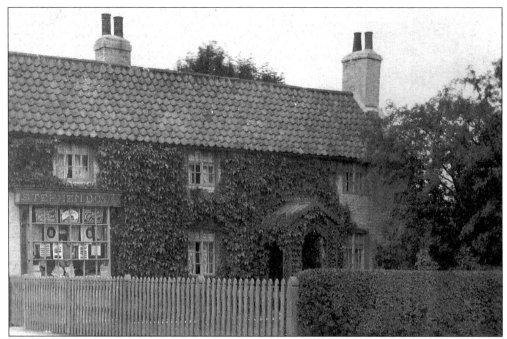

Stephen Dows' shop, between 1909 and 1919. Stephen Dows took over the shop belonging to G.W. Brown around 1909, but he was only there for a few years, as by 1919 Fred Dale is recorded as being the grocer there. The Dale family remained in business as grocers and drapers until recent times. They also made their own cakes on the premises, which they sold at a shop near the railway station.

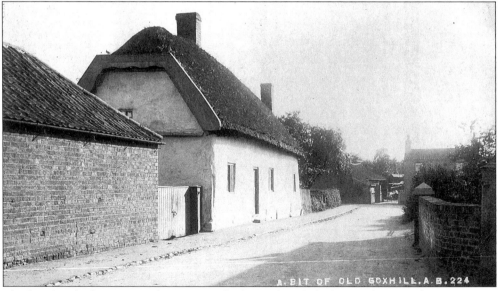

A. BIT OF OLD GOXHILL. A. B. 224

The last thatched cottage in the Square, which was demolished around 1920. Almost opposite is the garden wall to Ashfield, the home of George Henry Parker, the village blacksmith and photographer, who was responsible for many wonderful pictures of the village. His son, George Henry Jnr, inherited his talent and in turn recorded life in and around Goxhill almost until his death on 4 August 1990.

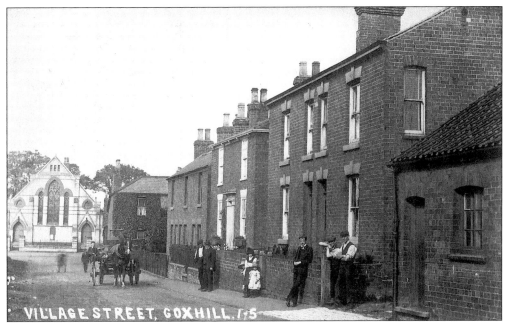

The Square in 1910. George Parker Snr would stood standing outside his blacksmith's forge to obtain this superb view of the Square. The ivy-clad building is Fernlea, an appropriate name for the house of John Sarjantson, the florist. Facing down the street is the Primitive Methodist chapel which was erected during 1890-1, and opened for worship in March 1892. The chapel, recently re-roofed, continues to be used today.

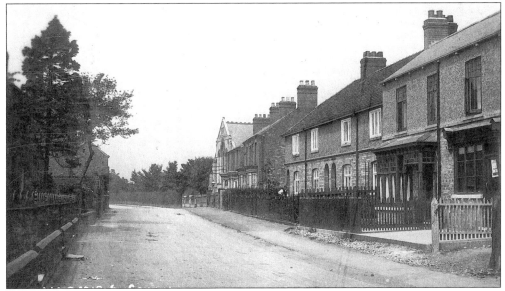

A very quiet scene in Chapel Street, *c.* 1925. Past the Primitive Methodist chapel, where the trees are, is Hawthorn Gardens, a nursery said to have been one of the largest in the country, with many greenhouses. The nursery was founded by Herbert Tyson and Cornelis Van Den Bos came from Holland in 1919 to organize the growing side. The stock was sold in Humber Street, Hull. This business has only recently shut down. The first building on the right is the premises of T.K. Wardle, the butcher.

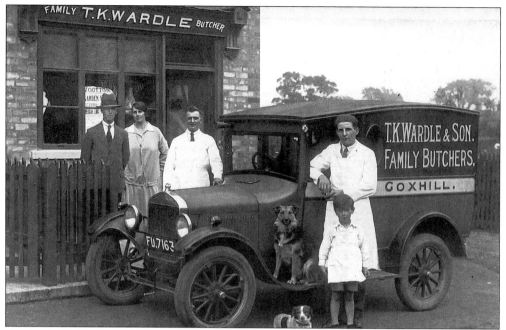

A splendid close up view of the butcher's shop in Chapel Street. The scene is complete with the delivery van, which, we were told by George Parker Jnr, was taken around 20 July 1928. Thomas K. Wardle wears a trilby and his wife is by his side; together, they ran the shop. Their son, Frank, is leaning on the van door, with younger son Wilf standing in front of him. Frank took over the business and later had a garage in the village and another in Barrow.

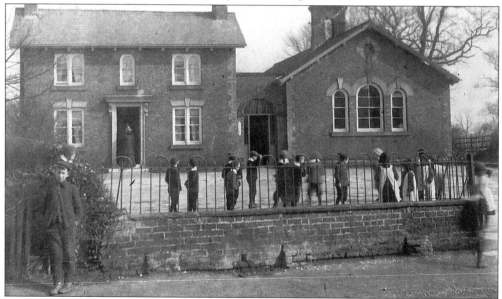

The school in Thorn Lane, known as Goxhill Wesleyan day school, around 1910. It was built in 1855 and could accommodate 250 children but by 1910, when William James Lewis was the master, the average attendance was 160. The master's house can be seen to the left of the schoolrooms. A new school, built to replace these old buildings, was opened in North End during the 1970s.

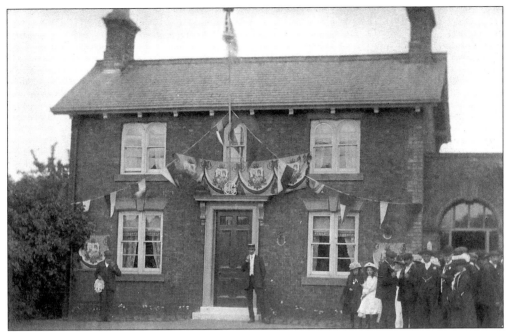

Enthusiastic celebrations for the Coronation of George V at Goxhill in 1911. Bunting was stretched across the front of the schoolhouse with pictures of the King and Queen also decorating the building. Everyone dressed in his or her Sunday best for the occasion.

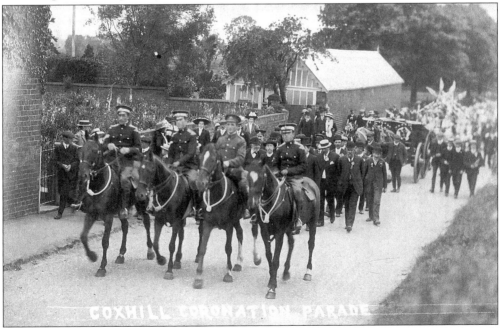

The festivities on Coronation Day, 1911. These included a well-photographed parade through the village led by military personnel on horseback, followed by local dignitaries. The procession is seen here passing New Hall, coming into the village along Howe Lane. Many decorated wagons complete the spectacle, each one, no doubt, hoping for a prize as the best one. This is yet another photograph taken by George Parker Snr who must have had a very busy day.

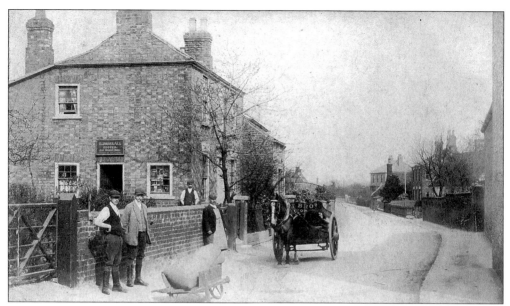

A shop and house on Howe Lane, now called White Cottage, at the beginning of the twentieth century. The way of life for people living in this rural area of Lincolnshire during the first years of the twentieth century is recorded for posterity in this scene. The shop and house, was where George Drinkall sold groceries and tobacco among other things. The horse and cart belonging to Hunt Brothers of the Anchor Brewery on Pasture Lane, Barton, appears to be waiting for a load of grain from Davey's warehouse next door. Nowadays you will find the Spar shop in between White Cottage and the Granary.

Two magnificent piebalds, born in Goxhill. They were a familiar sight in the village, until they went to Hull to work for a brewery there. Pictured by Barton photographer, Bert Parker, outside the warehouse belonging to Davey and Son, corn and seed merchants, is Mr Turner, the drayman, holding the reins.

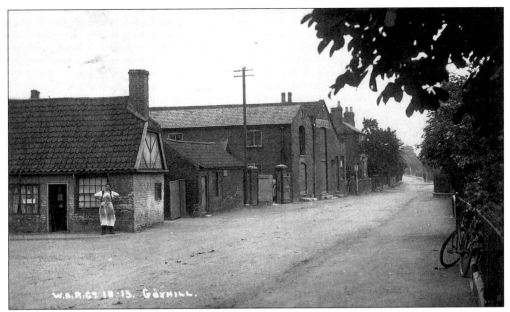

A long view of Howe Lane, around 1930. The buildings seen in the previous two pictures can be distinguished in this view of the road. The small building, facing, is a cobbler's shop on the corner of Westfield Road, the man standing in front is Harry Willford, who in addition to being a boot repairer, was also a special constable. This building was later demolished and replaced by a new one, a shop selling sweets and groceries. In turn, the shop was bought by Frank Wardle and it became his first garage.

Goxhill Tigers football club, 1947/8 season. The team, mainly made up of youth club members, was, left to right, back row: Ralph Naylor, John Ellis, Roy Lawrence. Middle row: Tony Atkin, John Guilliatt, Alan Barrick. Front row: ? Carratt, Ash Dent, Tom Stanley, Denis Coulam, ? Smithson.

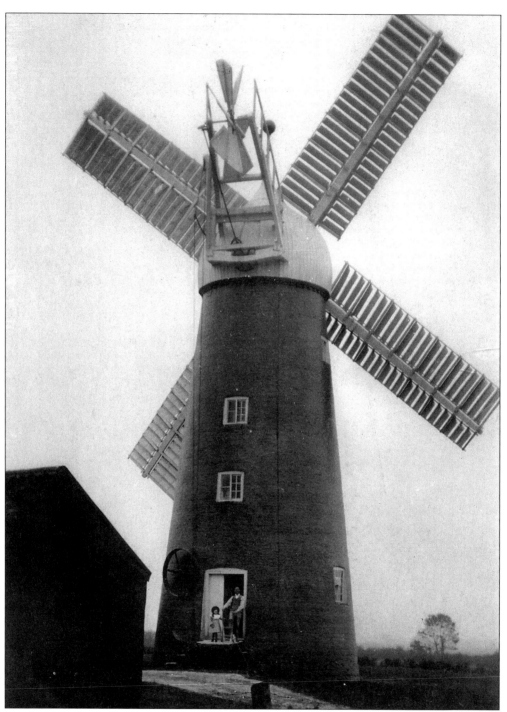

North Mill, Goxhill. Mr and Mrs Alfred Ironmonger sent this postcard picture of their windmill, North Mill, as a Christmas card to a friend. It is probably Alfred Ironmonger standing in the doorway with his daughter Blanche. The mill is a typical Lincolnshire tower mill with ogee cap, built in 1833 and worked initially by wind, but by the early 1920s it was powered by an engine. The sails were removed in 1934.

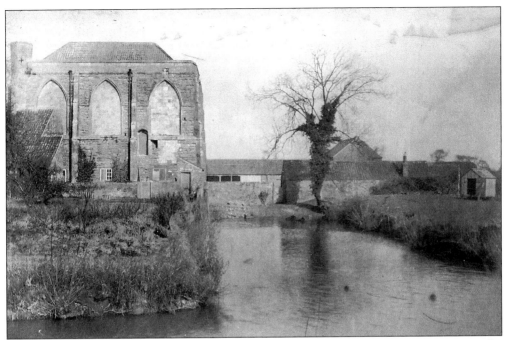

An uncommon aspect of Goxhill Old Hall in a study by Arthur West of Barrow, *c.* 1907. The Old Hall, a late fourteenth-century building, was a fortified Manor House with an adjoining mansion. Situated in South End, the moat surrounding it is clearly evident in this wintry scene. The property is presently occupied by the Hon. Mrs Hildyard.

The ruins of Thornton Abbey, about a mile and a half from the village of Thornton Curtis. The splendid entrance gate was completed around 1382 and this part of the abbey remains in a reasonable state of preservation. This peaceful place has had much written about it elsewhere.

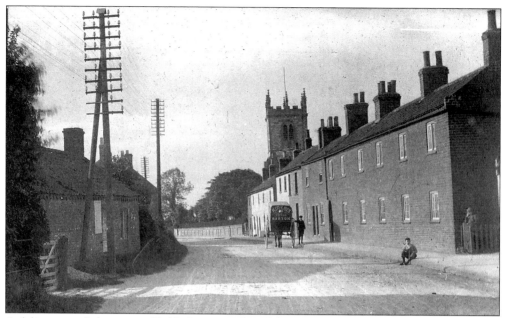

A delivery cart belonging to Kirkby's stores. They delivered goods from their premises in Barton five miles away, to this little village of Thornton Curtis. Their horse and covered cart can be seen in the main street and beyond the cottages is the church dedicated to St Lawrence.

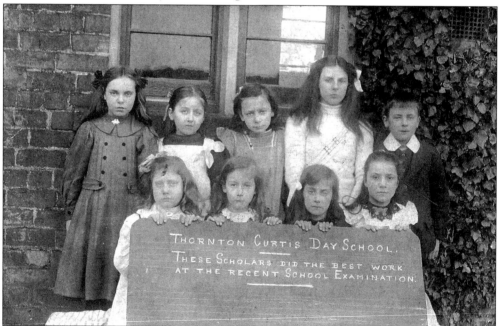

Thornton Curtis school, founded by John Ferraby Esq. of Wootton Hall and erected in 1873 to the memory of his wife. It was built on the road to Thornton Abbey, but the building has since been converted into a private house. These were the pupils who did the best work in a recent school examination, around 1910. Left to right, back row: Ivy Watson, Robina Altoft, Ethel Tomlinson, Rebe Barker, Peter Taylor. Front row: Rose Mundy, Jessie Ellerby, Clara Stamp, -?-, Emy Bordor.

Nine
Wootton and Ulceby

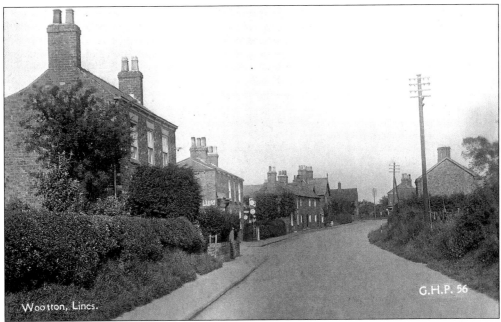

Wootton High Street, as it looked seventy years ago. The large house on the left is the post office facing on to Vicarage Lane. Herbert Green arrived in the village as postmaster and shopkeeper in 1928 selling everything 'from a pin to an elephant', according to his daughter, Anne Scott, the present postmistress. The next shop is a general store belonging to Mrs Arthur Parrott; her son looked after the petrol pumps. Hiram Hill, the cobbler, ran a successful business from the far end of the cottages next to the village school for thirty years.

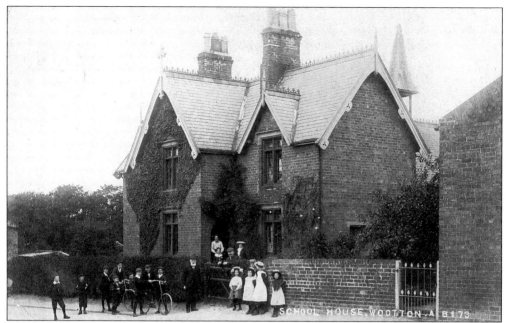

Christmas greetings from Mr William John Marsh in 1905. This picture postcard was sent from Mr William John Marsh, the head of Wootton village school, and his wife, who was also a teacher there. The main playground is to the left and there was a small one to the right of the schoolhouse. The house was built in 1863 when the school was rebuilt to accommodate up to 120 children.

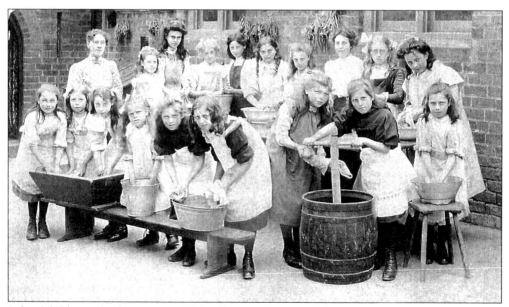

Schoolchildren of a bygone era. This glimpse of a school lesson almost a century ago, was recorded by the Barton photographer, Arthur Brummitt. It shows the senior girls' laundry class, with Mrs Marsh in charge, and was taken in the small playground with the doorway leading into the schoolhouse just visible on the left. It could well be a Monday as traditionally this was washday. The onions drying on the wall are probably from the boys' gardening class.

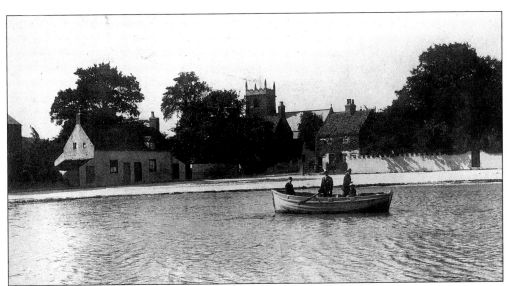

Wootton in 1912, with local folk enjoying a row on the pond on a lovely summer's day. If you were to dream of a peaceful English village, this is, perhaps, the sort of scene most of us would visualize in our mind's eye. Houses nestling among trees around the church in the centre, with cottages clustered around the village pond, or village green. Wootton is one of only a few North Lincolnshire villages to have retained its pond. This view is little changed and can still be enjoyed today. The house, Ivy Cottage, remains the same, but the stone cottages have been altered into houses.

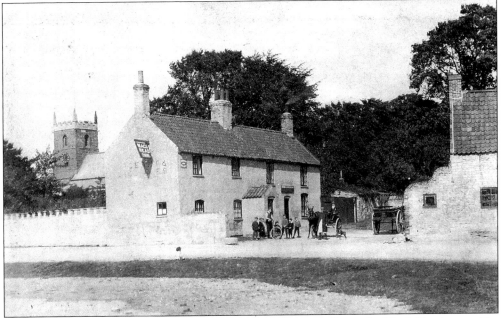

The Nag's Head in 1905. Sergeant's Brigg Ale is the beer on offer at the Nag's Head, served by the licensee, Annie Elizabeth Whitehead. Joseph Wilson ran a carrier service from Wootton at the time, to Barton on Mondays, Brigg on Thursdays, and Hull on Tuesdays and Fridays, so it is possibly one of his carts in the pub yard. A pub sign no longer hangs from the end of this building, across the road from the pond, as it is now a private house known as 'Lakeside'.

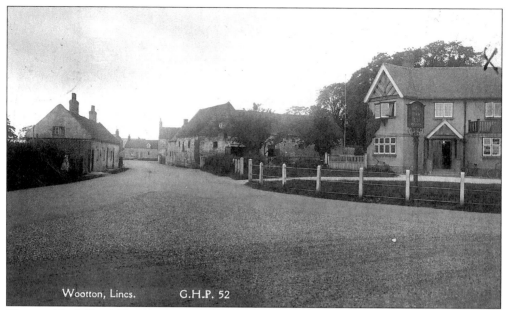

Wootton, Lincs. G.H.P. 52

The new Nag's Head, Wooton. Henry Coupland was the last licensee of the old Nag's Head and the first one when the new licence was transferred to a new building close by. The old pub can be seen jutting out from beyond the stone cottages which have gone, as have those to the left. This postcard view is postmarked 1931.

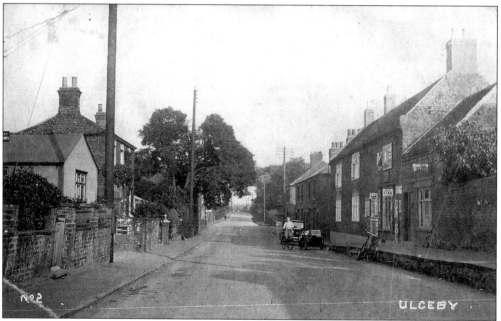

ULCEBY

Coming into Ulceby village from Wootton. The pavement on one side of High Street used to be much higher than the road until it was levelled in the 1970s. The raised path, called 'High Flags', can be picked out in this view from around fifty years ago. It is almost impossible to miss Emily Major's shop, covered with metal advertising signs, where she stocked a wide range of merchandise, including newspapers. The National Provincial Bank occupied the building next door, but was only open on Fridays between 10.30 a.m. and 2 p.m.

Ulceby school in the summer of 1908. These young people are sitting outside their school and pose for Mr West, the photographer from Barrow. Behind the children is the headmaster's house with the classrooms to the left. On the extreme left is the boys' entrance via the porch, while the girls went in at the rear of the school where the playground was too. Mr William Walker, the new headmaster, was to continue in this capacity until the late 1920s, when he was succeeded by Mr Ernest Nuthall. Nothing remains in Church Street of the school buildings; a new school for Ulceby has been erected on adjacent land.

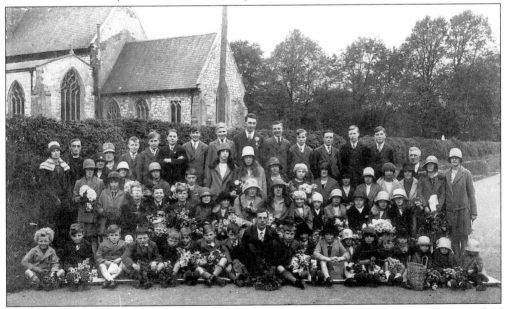

A large group of mainly young Sunday school members celebrating the Harvest Festival of 1928. Pictured on the road outside the church of St Nicholas with the children is the vicar, the Revd George Herbert Newton, who is standing with his wife on the back row. Sitting centrally on the front row is Mr Arthur Shaw, the Sunday school superintendent, who worked hard for the youth of Ulceby for many years.

The New Inn, Ulceby. Too many years have passed for most people to remember the New Inn, a beer house owned by the Tadcaster Tower Brewery, as it closed soon after the First World War. The Primitive chapel, on the opposite corner of High Street, was erected in 1889, but has not been used for worship for a very long time. At the end of the street is the old Brocklesby Ox public house.

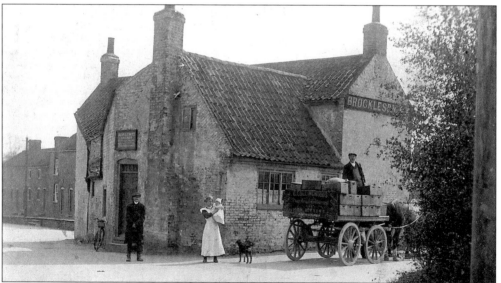

Brocklesby Ox public house in Ulceby. This fine moment of social history was captured by the cameraman of the time and shows a way of that has long gone. This postcard picture is postmarked 1914, and shows the old Brocklesby Ox which was soon to be replaced by a completely new inn on almost the same site. John S. Jewitt was the landlord, and the young lady with the child is thought to be a Miss Havercroft. How long would it take for the horse and rulley to travel the seven miles from the Barton firm of Charles Collingwood to bring the weekly supply of their hop bitters and aerated waters? The high pavement of High Street helps to locate the exact site of this building today.

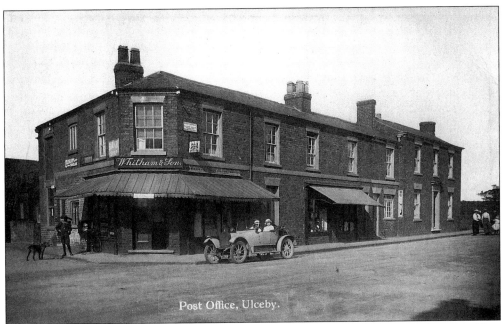

Two ladies arriving in style outside the post office at Whitham's store on High Street. Two generations of the Whitham family were in business here on a large scale until the Second World War, the last being Ernest Arthur Whitham. As early as the 1920s they had a lorry for delivering orders to customers in the surrounding villages. In addition to the post office and general store, clothes and linen, which were displayed in the window to the right, were also stocked.

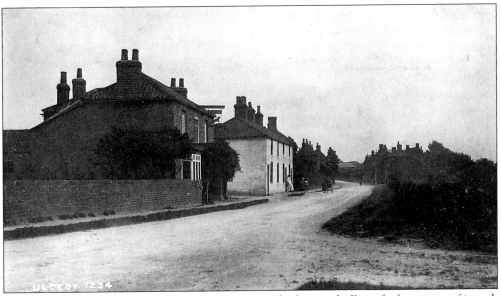

The Fox public house in Front Street. This pub once had a metal effigy of a fox as part of its pub sign, but it disappeared during the Second World War, when the pub was frequented by airmen from a nearby aerodrome. Rumour has it that the sign was dropped over Germany on a bombing raid; a surprise tactic that no doubt helped to win the war!

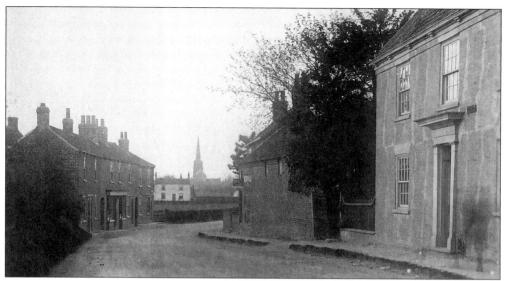

Front Street in the 1920s. Several tradespeople lived and worked in Front Street at this time including, in the row of houses to the left, Sarah Ellis with her general store, and Charles Ellis, the boot repairer. Charles Ellis also made boots for local farmworkers, costing £1 a pair, all the patterns hung round his shop. Fish and chips could be bought from the little shop at the end of the row and cycles from premises on the other side of the road. Time has taken its toll though, and each one of these businesses has now gone. The houses on the left have disappeared with them.

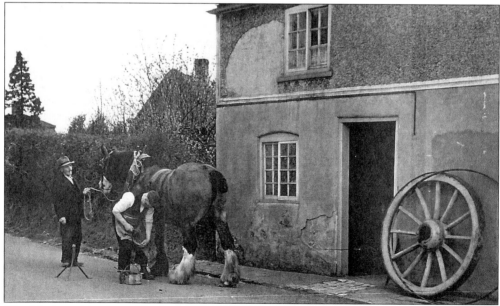

The blacksmith's shop, Ulceby. The community of the day tended to centre around the blacksmith's shop in many Lincolnshire villages, with craftsmen, farmers and local men all using the smithy. Harry Hookham, farmer of the Manor House, holds the reins of his horse, Bonny, while Martin Walker skilfully does the shoeing outside the forge in Front Street. A wagon wheel has been left against the wall, to be hooped later, a job that was conducted behind the shop.

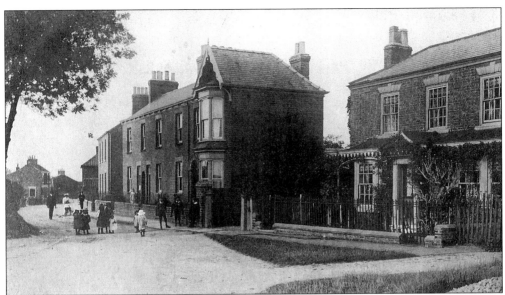

Coronation Gardens, Ulceby. Mention Coronation Gardens to the older generation and memories come flooding back of Bob Stamp, the tailor, who lived in the first house on the left in this view. He is remembered sitting near the window, making breeches for the local farmers and hunt servants at Brocklesby. William Stothard, the baker, was to be found half way down on the right, and was noted for his wonderful plum bread. 'Roseville', on the extreme right was once the home of the local doctor, Dr Roskilly.

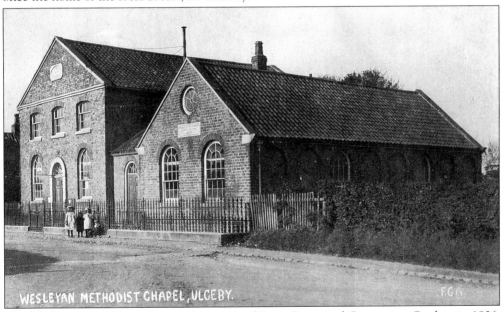

The Wesleyan chapel, standing on the corner of Front Street and Coronation Gardens in 1906. The chapel has undergone many changes and additions since this photograph was taken. The original chapel was founded in 1816, and the Sunday schoolrooms added in 1833. In 1908 the foundation stone for a new chapel was laid on 6 August and bricklaying commenced on 20 October on a site adjoining the schoolrooms. Miss F. Tombleson of Barton performed the opening ceremony on 4 March 1909 and the first preacher was the Revd A. Roebuck from Hull.

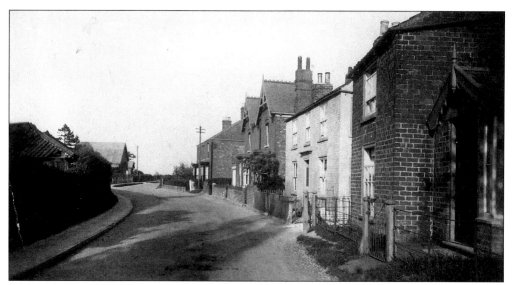

Although named Station Road, this part is now called Spruce Lane. This view, taken in the late 1920s, looks towards Ulceby's railway station, with the Seventh Day Adventists chapel in the far distance. Built in 1888 it is still in use today. In the foreground, on the right, the first two buildings have gone, but the white one is the Guest House, although at the time of this picture it belonged to Mr Parks the bricklayer. Beyond this was a general store run by Miss Fidell who sold everything from paraffin to groceries, tomatoes from her greenhouse and corn from Schofield's of Barrow. Now a hairdressing salon, it survives along with all these houses.

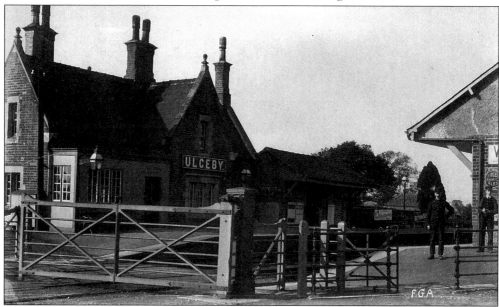

Ulceby railway station, a mile and a quarter from the village at Ulceby Skitter. The initials 'F.G.A.' show that Francis Ashton of Brigg came and took this photograph and the date on it is 1908. Revealed here are the extensive station buildings and two members of the staff; the stationmaster was George Richardson. The Great Central Railway timetables just visible on the wall were to be replaced by LNER ones in later years. Unfortunately today, none of these, nor any of the buildings remain, the station being merely a request stop.

Ten

South Ferriby, Horkstow and Saxby-all-Saints

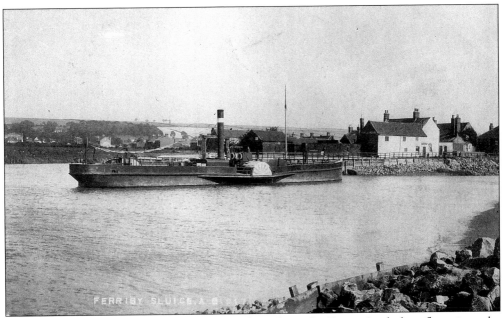

Ferriby Sluice, one mile west of South Ferriby, where the River Ancholme flows into the Humber estuary. The paddle steamer, *Her Majesty*, which sailed daily, except Sundays, between Hull and South Ferriby carrying passengers, goods and cattle, is anchored at the jetty known as Sluice Haven. The white building is the rear of the Hope and Anchor Inn with the landlord's name, Eli Scott Mouncey, above the door. The lock keeper's house is to its right. The steamer was broken up in 1912 to be replaced by the *Isle of Axholme*.

Looking towards the Humber, with several pleasure boats moored on the bank of the River Ancholme in the 1920s. Underneath the arches are sluice gates which are still lifted to stop the river from flooding. The whitewashed cottage was lived in by Mrs Benson and the building beyond was a combined house and barn, with wagon sheds underneath. Neither dwelling now remains.

FERRIBY SLUICE. A.B. 117

The outfall to the River Ancholme in the foreground, 1918. The buildings seen on the other side of the river disappeared around 1960. This postcard view is dated 1918, when Mr Henry Howell lived in the first cottage. He kept rowing boats on the river for hire in the summer time in addition to being the village's coal merchant.

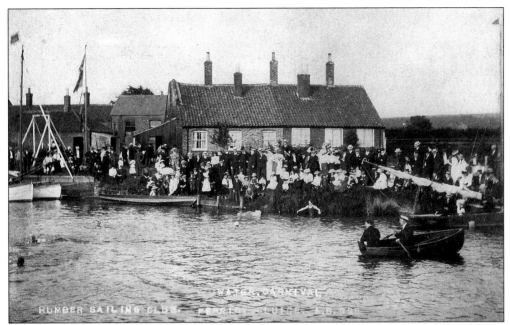

The Water Carnival, held annually on August Bank Holiday. Prior to 1914 the annual Water Carnival was the high point of the summer season on the Ancholme when people flocked from both sides of the Humber to Ferriby Sluice. It was a picnic party occasion for families to enjoy watching the varied competitions on either side of the sluice bridge. The buildings here can be noted on the previous picture.

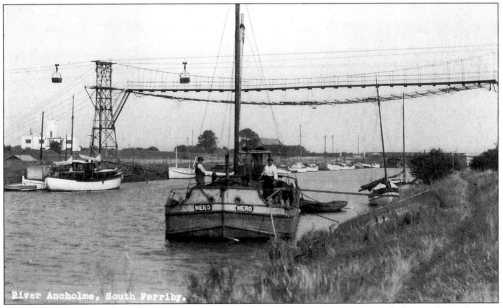

The halcyon days of the 1950s on the river with many river craft moored alongside its banks. The sloop *Nero* had by this time been converted from sail to engine. On the left is the owner, John Franks, and on the right is Cyril Harrison. The boat was mainly used for carrying bricks from the brickyard close by. The buckets, above the Ancholme, carried chalk from Ferriby quarry to Eastwood's Cement Works.

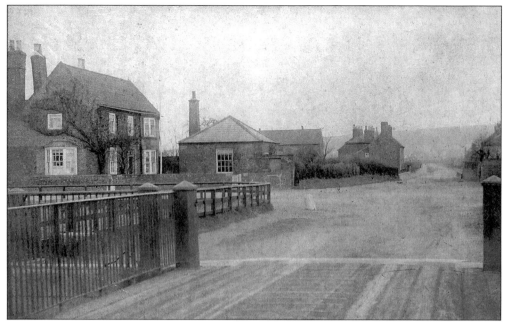

Moving from the bridge over the lock gates towards South Ferriby in 1906. The first house on the left is the home of the lock keeper, Frank Straw. In addition to being in charge of the arrangements for shipping entering and leaving the River Ancholme, anglers would get tickets for fishing on the river from his office in the low building close by. In those days, there was a swing bridge worked by hand later replaced by an electrically operated lifting bridge.

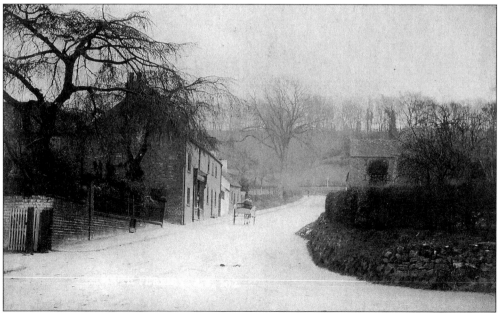

Sluice Road around 1905. With the Ancholme valley below and the Lincolnshire wolds ahead, we find the village of South Ferriby, three miles from Barton. The shop on the left is run by Joseph Beacock, a grocer and draper; it is the only shop remaining in the village, is still a general store and is now the post office too.

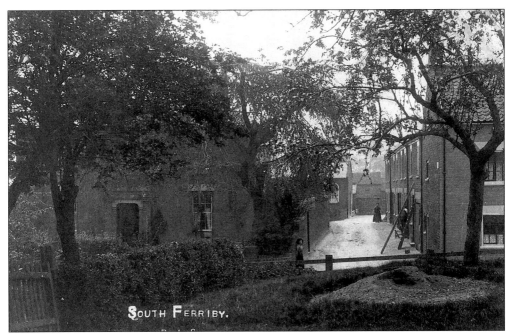

Farrishes Lane, by the side of Beacock's shop. The large trees are almost hiding 'The Elms', the home of Henry Walker, the farmer, nicknamed 'Whistling Rufus'. The houses on the right remain today, as does the Wesleyan chapel, but the farm buildings in the distance are no more.

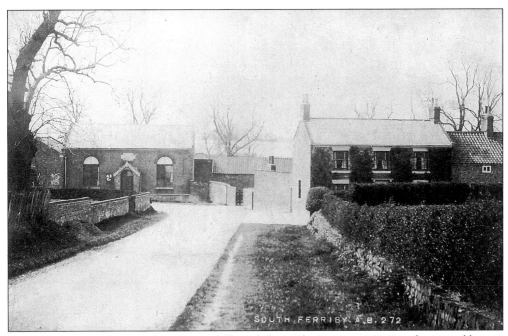

A view of Farrishes Lane looking from Cliff Road along The Rise, *c.* 1908. It is dominated by two buildings, the Wesleyan chapel, built in 1839, and Holly House, a farmhouse, where the Misses Sarah and Alice Pocklington lived. Bungalows have now been built on the land to the right.

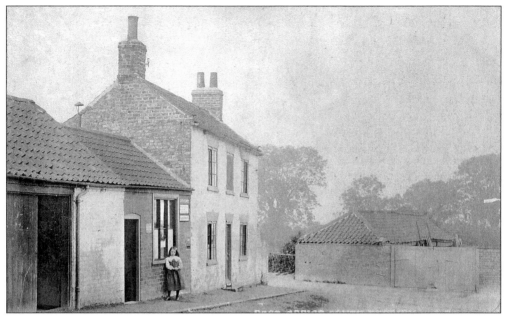

'I am writing in the post office here on the other side. Have crossed the Humber in a yacht, but never any more – Maggie.' This is the message on a 1907 postcard view of the building at the corner of Low Street and the street known today as Old Post Office Lane. Leaning against the window of the little post office is either Edith or Dorothy Andrew, daughter of Cook Andrew, the postmaster, who was also a joiner and wheelwright. The family lived in the adjoining house.

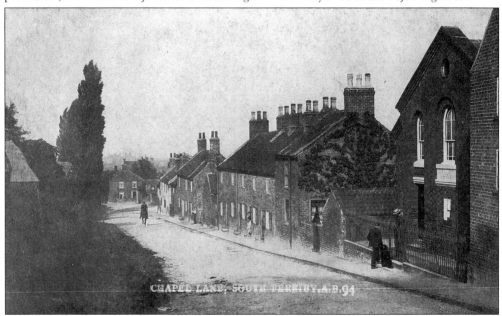

Chapel Lane, South Ferriby. South Ferriby had two chapels, the Wesleyan in Farrishes Lane and the Primitive Methodist at the top of Chapel Lane, since renamed School Lane. At the bottom of the lane is the Nelthorpe Arms kept by Thomas Surfleet. The schoolmaster's house is beyond, facing up the incline. Edwin Shrigley the master for twenty years was a well-respected man. He died in 1914.

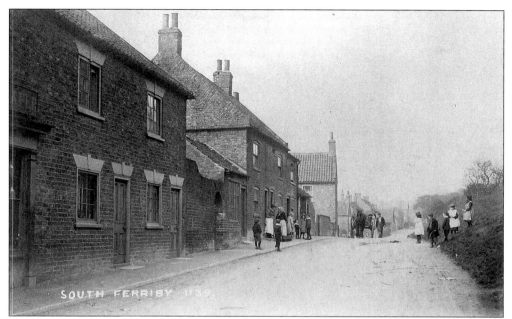

Looking into the village from Horkstow. This is a delightful scene from almost a century ago when children played and women shared the latest gossip. Horses were still the mainstays of the farmers of North Lincolnshire. Perhaps this one pulling a cart was a regular visitor to Harry Clark, the blacksmith, further down the street. Percival Hebblewhite, the draper and grocer, had his shop here in the High Street, while further along past the ladies was a fish and chip shop.

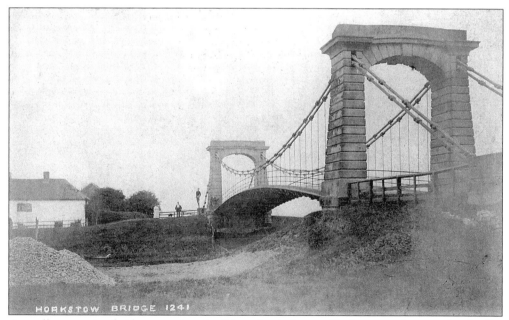

A small suspension bridge spanning the River Ancholme at Horkstow, only a couple of miles from the world famous Humber Bridge at Barton. Built in 1835-6 by John and Edward Walker, this remarkable structure, a superb example of early engineering, remains in as good condition today as in this fine postcard view of 1906.

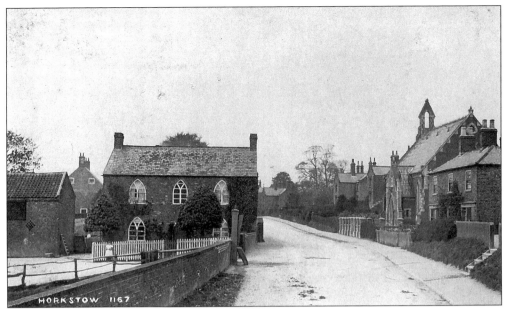

Horkstow's main street, looking towards South Ferriby in Edwardian days. Holly House, a smallholding on the left, was to be occupied in 1914 by the Tear family, whose daughter still lives in the village. At the entrance to the stackyard is the village pump where water barrels were filled and delivered to the houses on the hillside. Opposite Holly House is the Wesleyan chapel which, after closure, became the village hall. The opening ceremony was performed on 11 January 1931, but today, minus the bell tower, it is used as a garage.

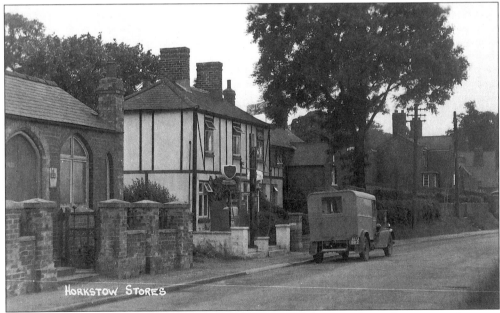

Tommy Stark's van, parked outside the post office village stores and petrol pumps in the main street. Tommy lived in Saxby and called his van 'Ivy'. Local folk can recall many happy outings in this late 1940s version of a present day minibus. The shop closed in the 1980s, but one petrol pump remains, re-sited at the side of the house.

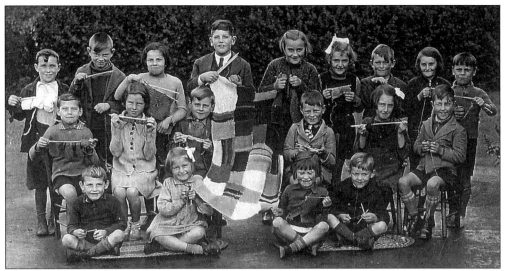

The children of Horkstow school with their teacher Miss Bird in 1942. They all learned to knit (to varying standards apparently) and made knitted squares for the war effort. The squares were then joined up to make blankets by their teacher. Left to right, back row: P. Gray, D. Lacey, M. Willoughby, T. Maw, B. Willis, G. Noon, R. Maw, C. Waddingham, C. Willoughby. Middle row: C. Dowman, V. Baguely, G. Harrison, F. Thorley, A. Maw, L. Marrows. Front row: D. Dowman, M. Maw, J. Thorley, I. Noon.

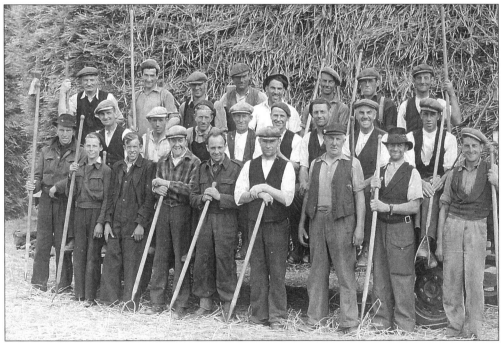

A gang of happy Horkstow farmworkers after a successful harvest at New Holland in 1947. Left to right, back row: ? Drew, C. Holland, Bill Roberts, W. Hurton, A. Ward, R. Scott, Bill Hebblewhite, W. Hoodless. Middle row: J. Harrison, A. Milson, W. France, P. Atkin, J. Dawson, G. Smith, C. Dowman, H. Ward, J. Kendall. Front row: ? Dowman (C. Dowman's son), Bill Gray, B. Dawson, H. Bell, Bob Broughton, G. Harrison, C. Willoughby, J. Milson.

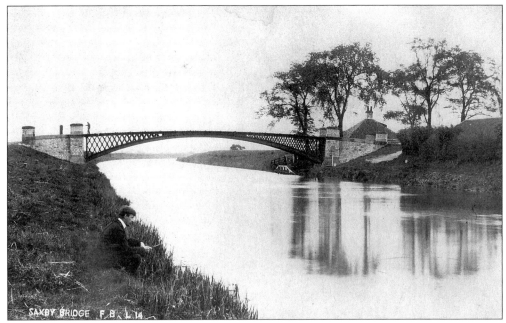

The River Ancholme as it flows beneath a typical Ancholme bridge on its short way to Horkstow, South Ferriby and finally the Humber, probably a distance of two miles. Saxby bridge is around a mile from the village and remains in as fine a condition as this 1905 view of it. No trace remains, however, of the little house and the trees surrounding it.

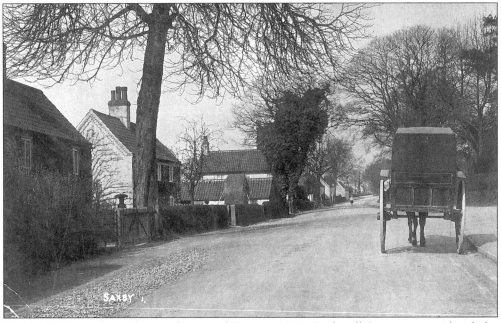

Saxby-all-Saints, five miles south-west of Barton, 1919. Saxby-all-Saints is considered the prettiest of the low villages with its colour washed cottages lining the main street. These were mainly occupied by farmworkers employed by the squire, and have been preserved and brought up to modern standards. The carrier's cart could be on its way back to Barton and perhaps belonged to Tutills who delivered goods into the village.

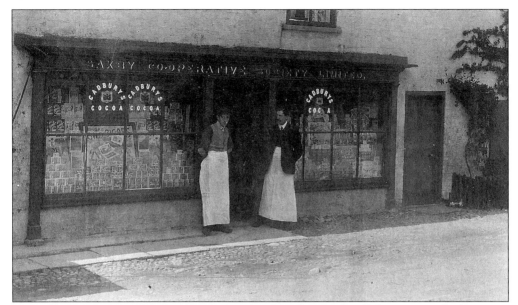

The village's Co-operative Society store. The fact that Saxby-all-Saints once had its own Co-op store was remarkable for such a small community. Until around 1920, John Gledhill was the manager and had been since the turn of the century. He then, with his wife, took over the store. Later it was owned by Henry Taylor, son of Joseph Taylor, the famous local folk singer. His daughter, Mary Sedman, continued the business until, in common with most village shops today, it closed.

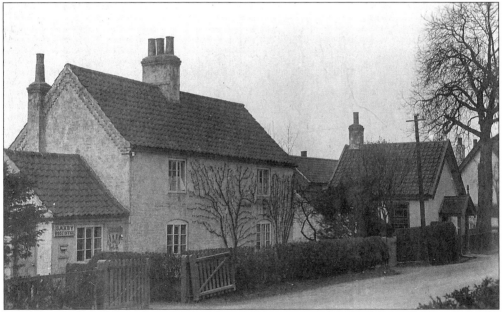

A poster, advertising the British Army, can be seen to the right of the window at Saxby post office towards the end of the First World War. Joel Hebblewhite was the sub-postmaster as well as the local boot and shoemaker. The post office moved to the village stores when Mr Gledhill became postmaster. The small building with the porch is the Reading Room which had been opened in 1882. It has now been altered to provide a garage for the house beyond.

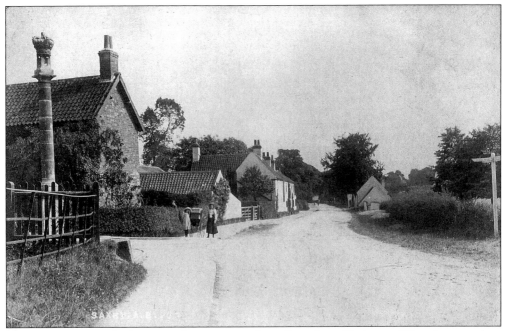

The main street in Saxby soon after entering the village from Horkstow. The photographer, Arthur Brummit of Barton, travelled to Saxby in 1909 to take this enchanting picture. The two children with the stylish pram are outside Fountain House. Close to the gate, we are informed from this postcard, is a youth named J. Woodcock. A little further down is the blacksmith's house. The quaint road sign indicates ways leading to Saxby Mill, Horkstow and Barton, Brigg, and to the right, Saxby Bridge.

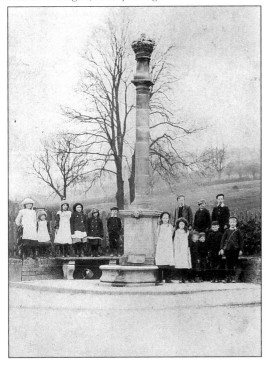

Children gathered around the drinking fountain for the photographer, just a few years after it was erected in 1897 to commemorate the Diamond Jubilee of Queen Victoria and in memory of Frederick Horsley. He died on 21 May 1897 having been the steward of the estate for forty-two years. Horses enjoyed a welcome drink from the fountain which was restored in 1977 to commemorate the Silver Jubilee of Queen Elizabeth II.